IMAGES
of England

CENTRAL
BIRMINGHAM
1870-1920

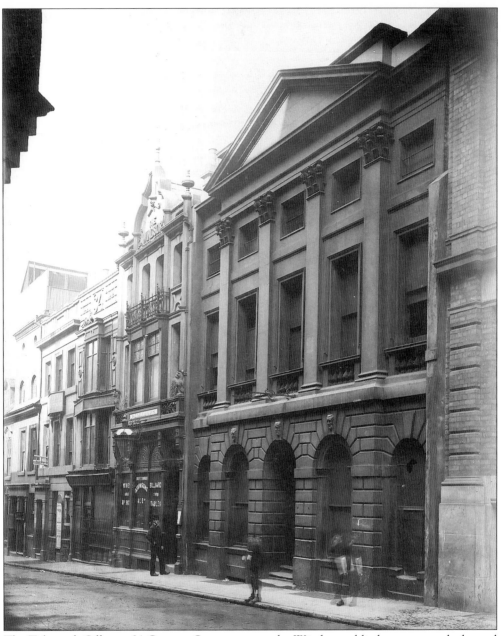

The Telegraph Office at 31 Cannon Street, next to the Windsor public house, towards the end of the nineteenth century.

IMAGES
of England

CENTRAL BIRMINGHAM
1870-1920

Compiled by
Keith Turner

TEMPUS

First published 1994
Reprinted 1998, 2000, 2002
Copyright © Keith Turner, 1994

Tempus Publishing Limited
The Mill, Brimscombe Port,
Stroud, Gloucestershire, GL5 2QG

ISBN 0 7524 0053 3

Typesetting and origination by
Tempus Publishing Limited
Printed in Great Britain by
Midway Colour Print, Wiltshire

Contents

Introduction

Ten years, even five years ago, the centre of Birmingham was a dispiriting place, post-war planners and developers nearly having achieved what the ravages of the Second World War had failed to do: destroy the heart of the city. A dual-carriageway ringroad of concrete flyovers and underpasses obliterated much of the periphery of the historic centre and, like a weighty yoke, began to slowly squeeze the life out of central Birmingham. Small, specialist shops were forced to close, victims of soaring rents, washed away on a relentless tide of burger bars and pizza parlours, designer boutiques and 'gift' emporiums. Many pubs suffered similar fates, even cinemas too - often to become carparks. Not for nothing was Birmingham known nationally as the city that put the motor car above the people and in the case of its soulless pedestrian underpasses, quite literally so. The nadir of 'development' was perhaps reached when serious consideration was given to constructing a new main line station well away from the centre, simply for political reasons, leaving New Street Station in effect on a branch line.

Today, let us give thanks, things are changing for the better. Slowly. Will it ever be like it once was? No: nothing ever is. The Birmingham city centre of a hundred years ago is a different place, a lost world that has slipped from the remembrance of individuals, remaining only as a collective memory conjured up by old photographs. A hundred years ago there were no cars, no motor buses in the streets, though pollution was much in evidence from the horse-drawn vehicles and steam trams which met the transport needs of the day. The motor car was soon to appear though, and the horse buses and steam trams gave way to their motor and electric successors. This was the time of Birmingham's rise as a major manufacturing centre, a rise that paid for the wholesale improvement of the lot of its inhabitants. Despite the post-Second World War ravages, much of the city centre of the late nineteenth and early twentieth century survives like a skeleton of what once stood: here a roadway coming to an abrupt and artificial end, there a glorious terracotta-faced building between two concrete

monstrosities with, most poignant of all, one bearing a blue plaque stating quite shamelessly: 'On this site stood...'

With the help of these photographs (chosen from the collections held in Birmingham Central Library) one can see once more what stood on these sites - where people lived, worked, shopped and spent their leisure hours. One can see also - and the photographs are grouped to reflect - how the focal point of the city, its very centre, has moved slowly northeast from the Bull Ring and the markets up New Street to Victoria Square. The shift continues, with the new Centenary Square destined to become the next focus.

All cities change constantly for it is in their very nature to do so. Today the city centre is at long last being reconstructed again, seemingly for the better as the centre is pedestrianized and given back to the people. A century ago it was being reconstructed, definitely for the better, as the dirt and squalor of an older age was swept away and the modern amenities we take for granted provided in a city to be proud of.

One
The Old Town

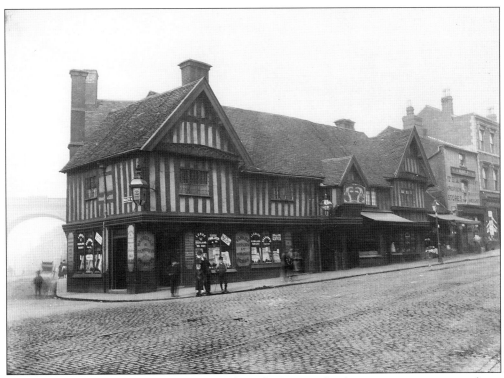

The Old Crown Inn, 1890, in Deritend High Street, the historic eastern approach to Birmingham.

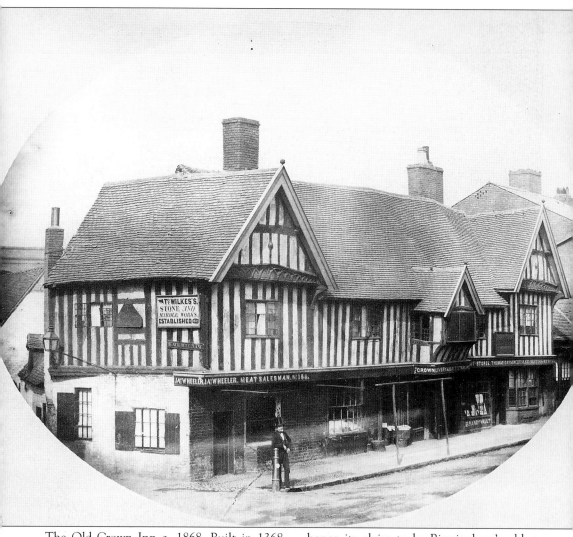

The Old Crown Inn *c.* 1868. Built in 1368 — hence its claim to be Birmingham's oldest building — probably none of the original structure remained five hundred years later.

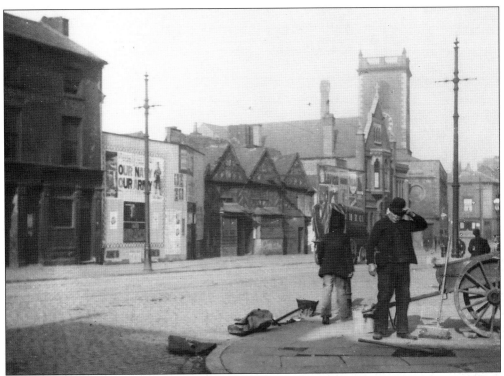

Roadworks in Deritend High
Street, 1908.

A house and garden in Deritend
c. 1910, overlooking the River
Rea.

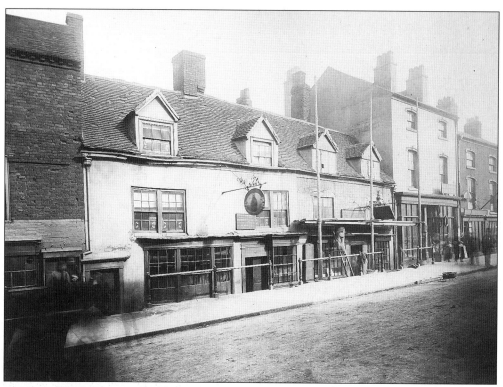

The Leather Bottle and Three
Crowns inns in Deritend
c. 1870. Both were demolished
some twenty years later.

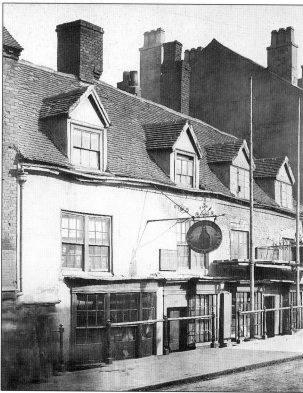

A closer view of the Leather
Bottle with its unusual circular
sign.

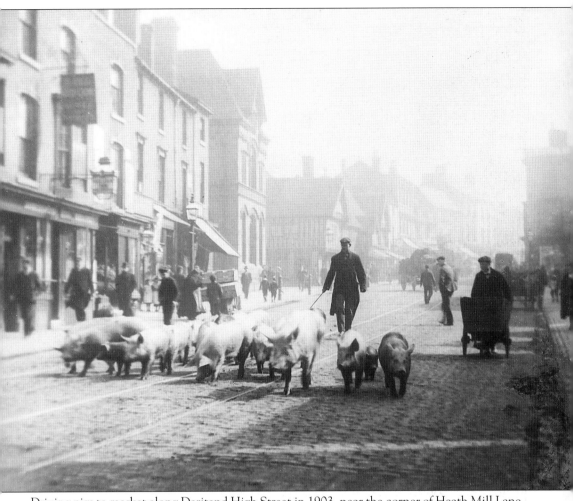

Driving pigs to market along Deritend High Street in 1903, near the corner of Heath Mill Lane.

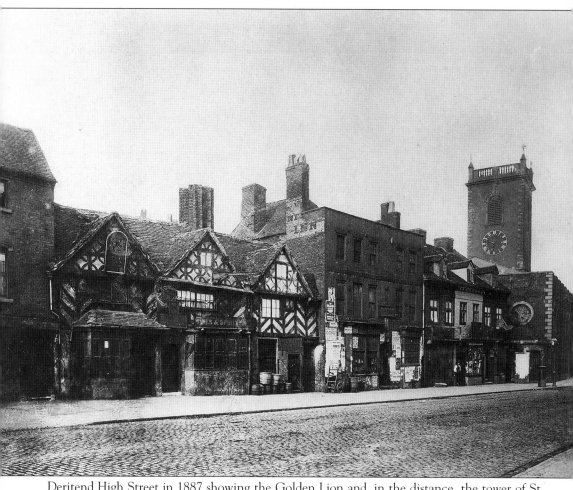

Deritend High Street in 1887 showing the Golden Lion and, in the distance, the tower of St John the Baptist (demolished in 1947).

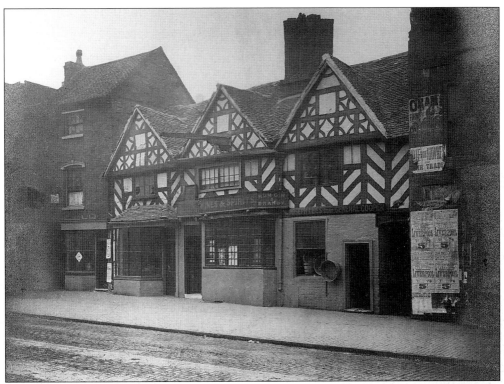

The Golden Lion: front ...

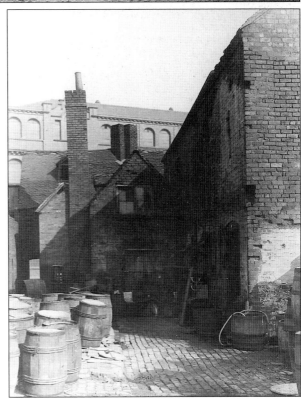

... and back, when still in use ...

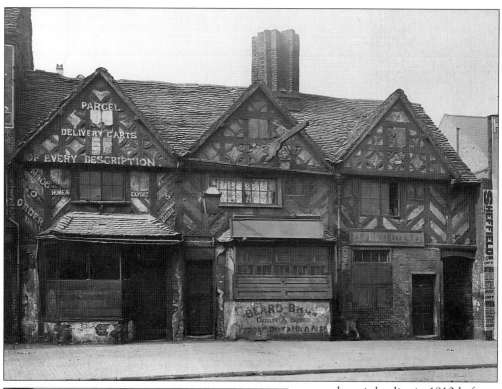

... and semi-derelict in 1910 before it was dismantled and re-erected in Cannon Hill Park.

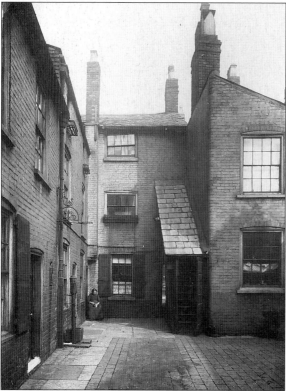

Between Deritend and the Bull Ring lies Digbeth, once a residential area full of houses and back yards like these.

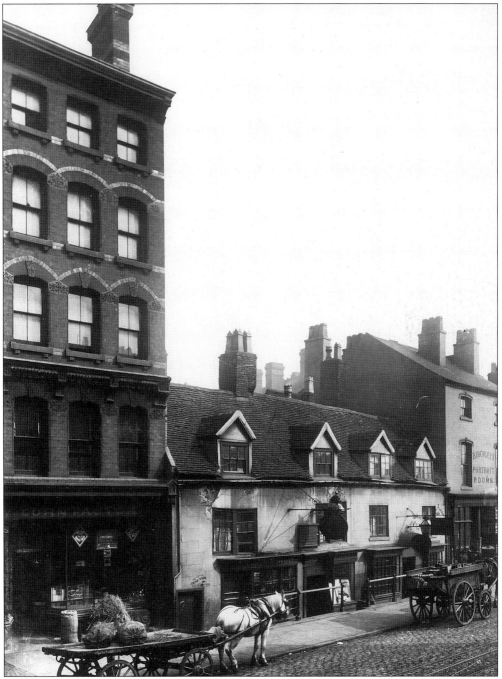

Contrasting roofs of the old and the new in the 1890s before the Leather Bottle and the Three Crowns were demolished. The site is now a car showroom.

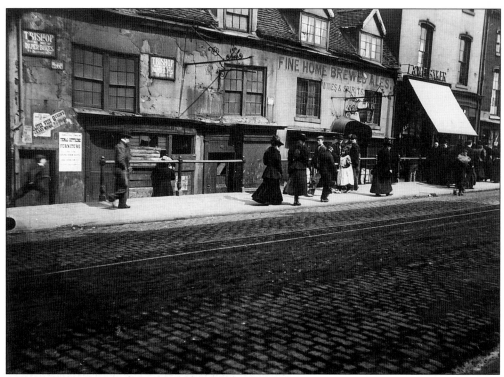

The same building in 1900 shortly before its demolition. The two hanging signs have already disappeared.

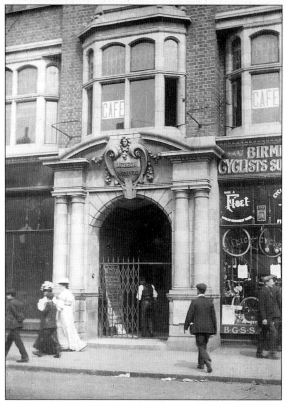

The ornate doorway of the Digbeth Institute, 1908, with the very latest in two-wheeled transport in the shop next door. Opened as a social and religious centre in 1908, the Institute closed in 1954.

The now-obliterated Well Street in Digbeth. The sixteenth-century building on the left is Assinder's Tripe House (demolished 1893) which specialised in tripe and cow heel suppers at seven o'clock of an evening.

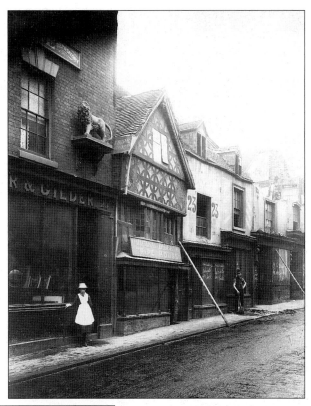

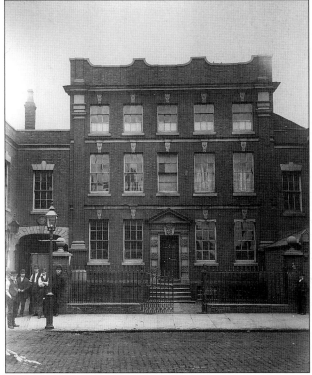

The old Battery opposite Rea Street in Digbeth in 1886. (Battery was the name given to the process of hammering out metal artifacts for which this area was noted). The site was later occupied by the Digbeth Institute.

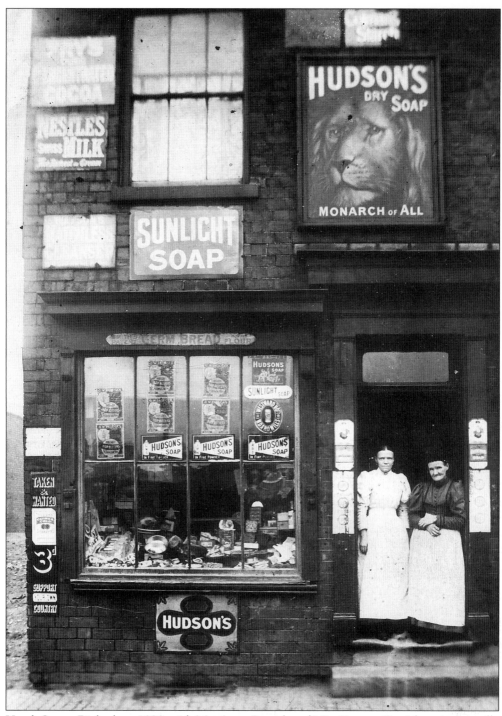

Heath Street, Digbeth, *c.* 1890, with Mrs Anne Patrick and Miss Frances Patrick posing proudly in their corner shop doorway.

Two

Market Life

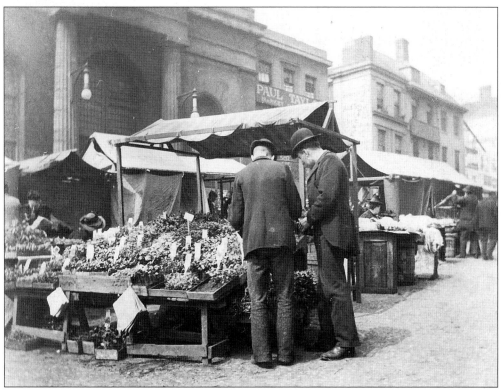

The open-air Flower Market, 1898, in the Bull Ring and markets area between Digbeth and the shopping centre.

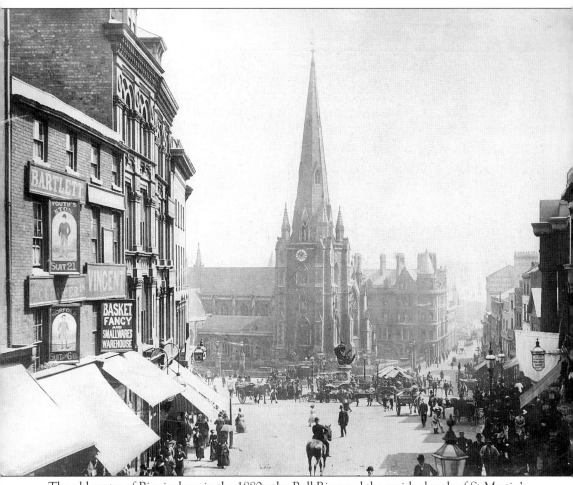

The old centre of Birmingham in the 1880s: the Bull Ring and the parish church of St Martin's.

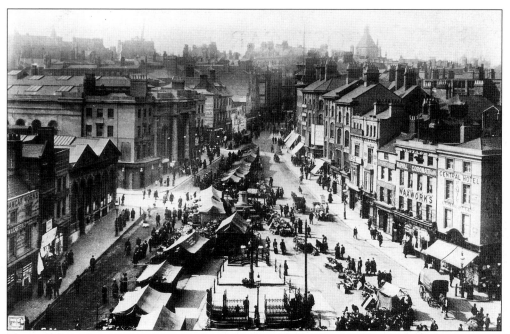

The Bull Ring from St Martin's steeple around 1905 looking towards New Street.

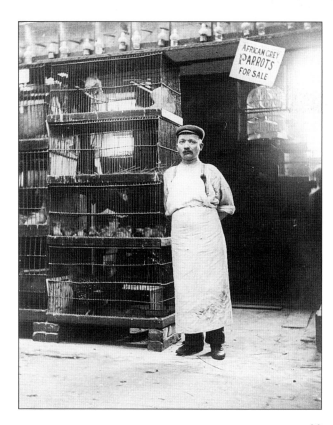

A typical Birmingham market trader, in this case selling caged birds.

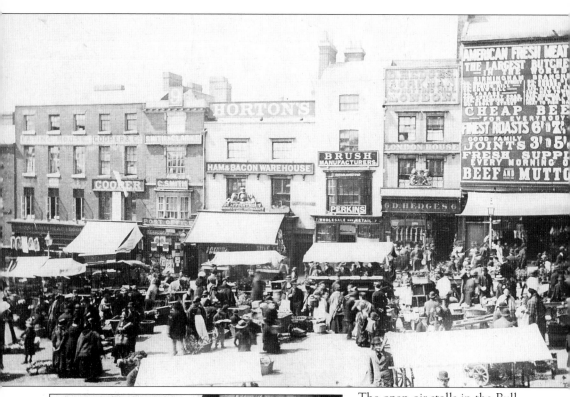

The open-air stalls in the Bull
Ring, *c.* 1886.

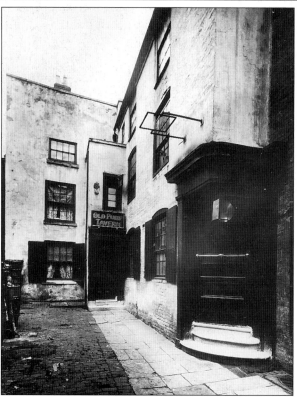

The Pump Tavern in the Bull
Ring. No area of the old town was
very short of public houses.

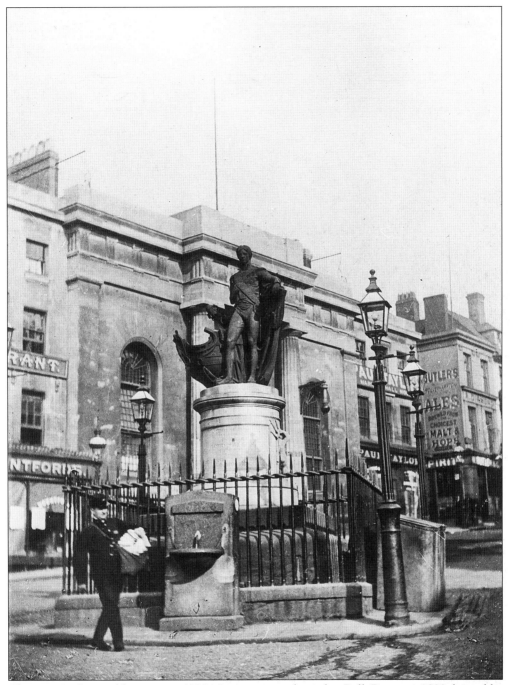

The town's first public statue, 1898. It was erected in the Bull Ring in 1809 by public subscription to commemorate Nelson's victory at Trafalgar.

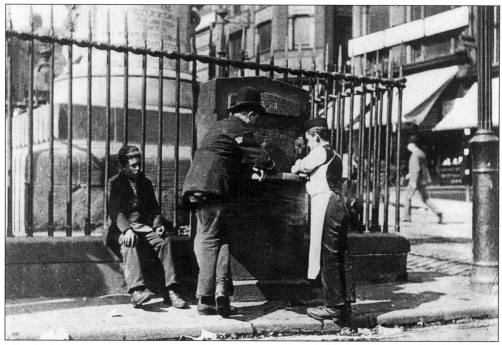

The drinking fountain at the foot of Nelson's statue. After the redevelopment of the Bull Ring the statue was re-erected in 1961 close to its original site.

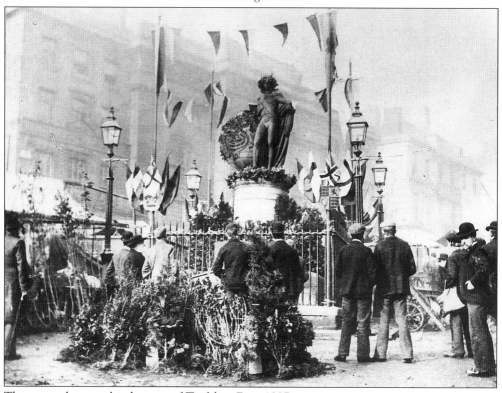

The statue decorated in honour of Trafalgar Day, 1897.

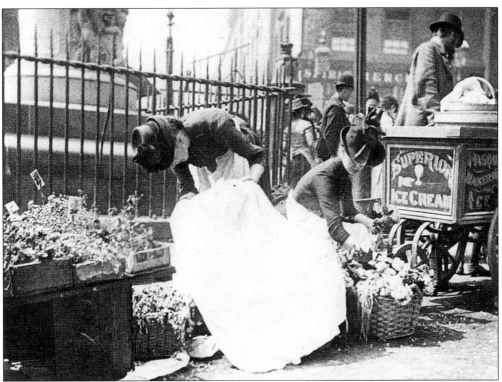

Flower sellers in the Bull Ring in 1892 with a mobile 'superior ice cream' salesman behind.

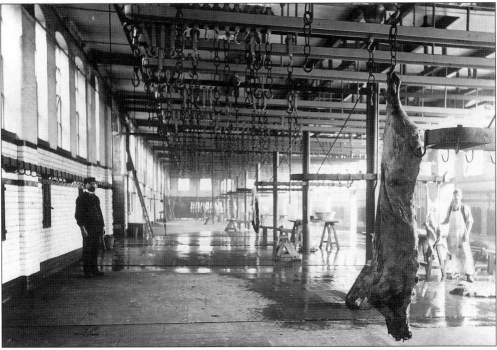

The covered market occupied a large site with a number of buildings, this being the public slaughter hall for cattle and sheep.

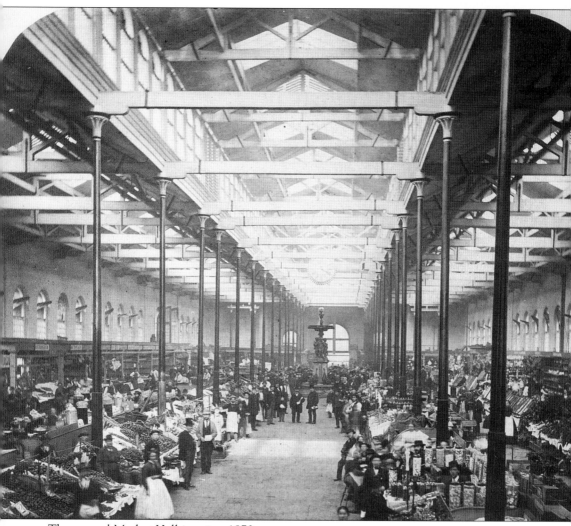

The general Market Hall interior, 1870.

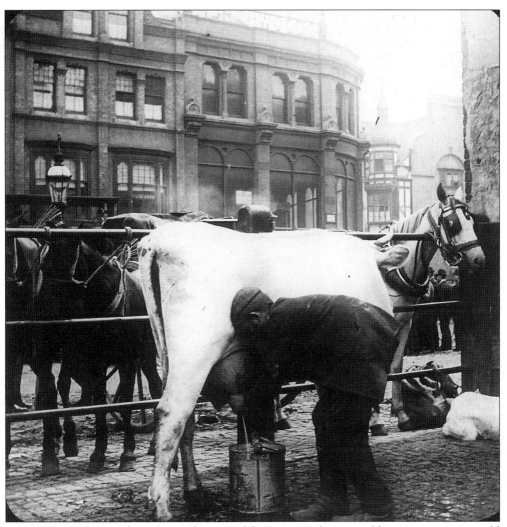

In the open-air livestock market at the turn of the century when age-old country routines could still be seen in the heart of the city.

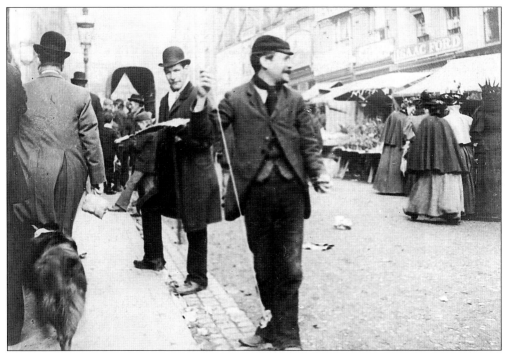

Street traders hawking their wares of cheap jewellery and toys — for the manufacture of which Birmingham became notorious — in the Bull Ring, 1897.

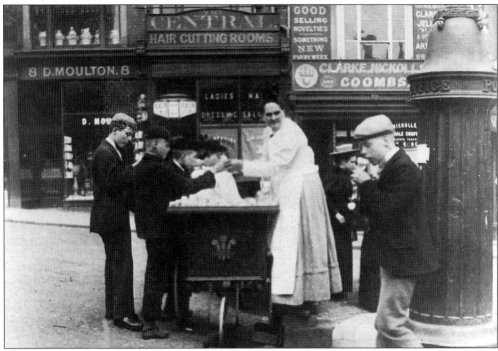

Another ice cream seller in the Bull Ring, 1897, with a very satisfied customer. The pillar box on the right was one of three prototypes from Smith and Hawkes' Eagle Foundry on Broad Street. Mistakenly produced nearly eight feet high, no more were made!

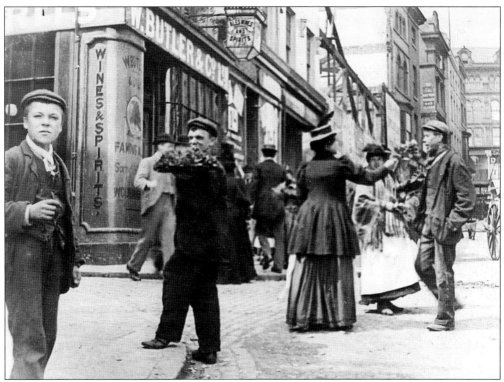

Neapolitan violet sellers in the Bull Ring in 1896 near the corner of the High Street.

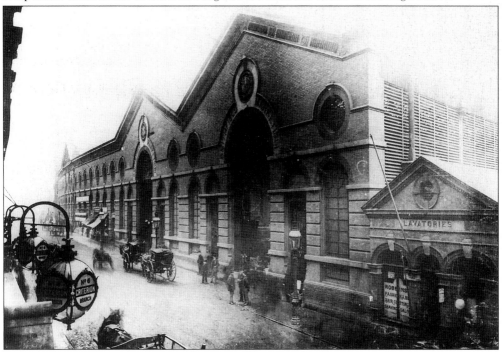

The impressive facade of the Smithfield Meat Market in Moat Row, 1890, just off the Bull Ring.

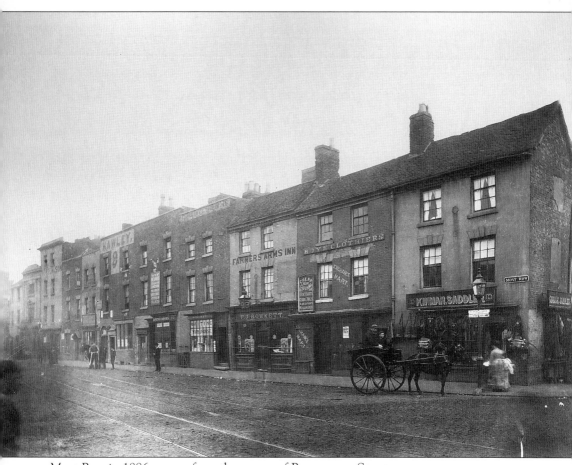

Moat Row in 1886 as seen from the corner of Bromsgrove Street.

Three
Along the Great Divide

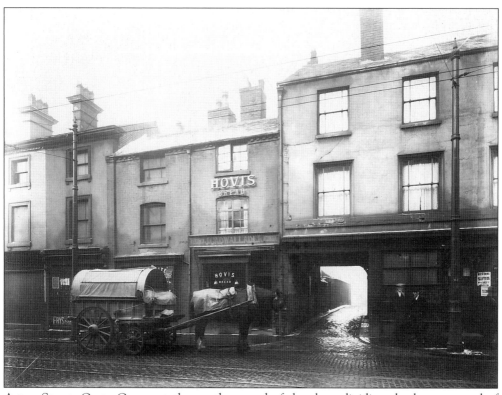

Aston Street, Gosta Green, at the northern end of the slope dividing the lower ground of Digbeth, the Bull Ring and the markets from the shopping centre.

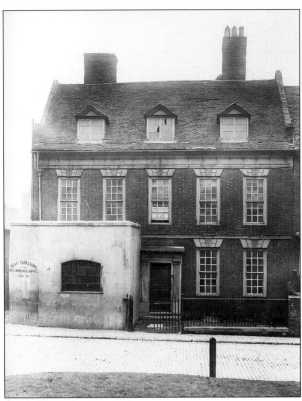

Farther south was Park Street. This was No. 18, once a desirable residence on the edge of the early metalworking district.

Less desirable was a working family's dwelling such as this: No. 5 New Vale Court, Park Street, in 1905.

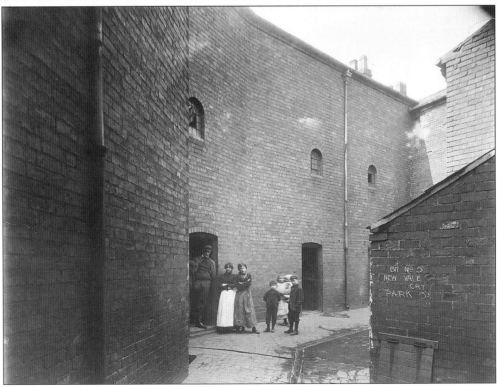

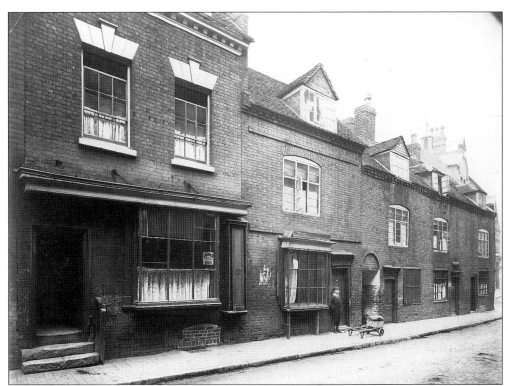

Somewhere between the previous two dwellings on the social scale in 1904 were Nos. 90 to 94 Park Street.

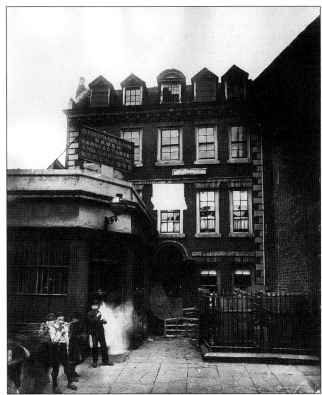

Park House, Park Street, c. 1890. Another middle-class residence though by this date its imposing frontage had been somewhat marred by a tacked-on building.

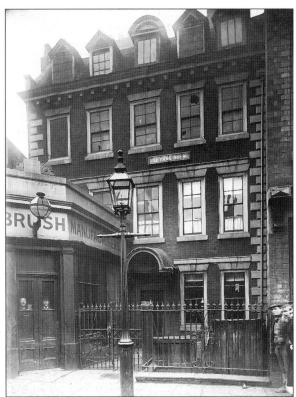

The same house five years later, now looking rather smarter and benefiting from a new gas street lamp outside.

Parallel to Park Street lies Moor Street, one of Birmingham's oldest streets (and previously known as Mole Street). This was the north side with its mix of houses, shops and commercial premises typical of the period.

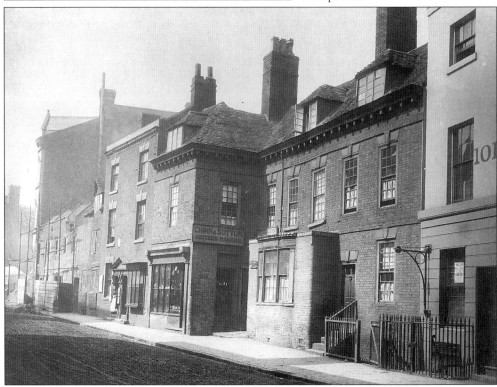

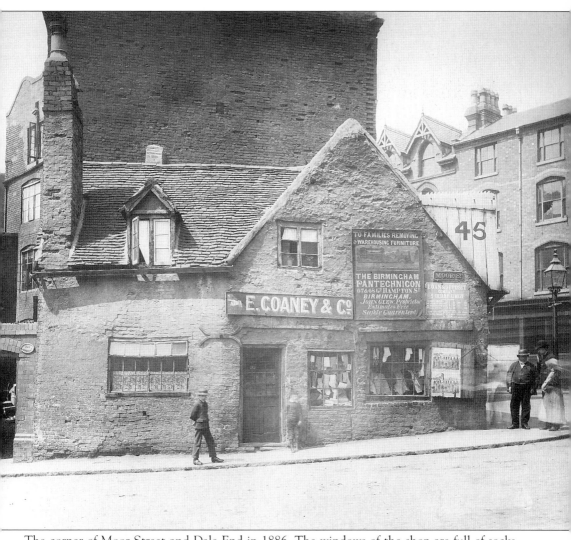

The corner of Moor Street and Dale End in 1886. The windows of the shop are full of socks, proving that there is nothing new under the sun, at least not in the retail world.

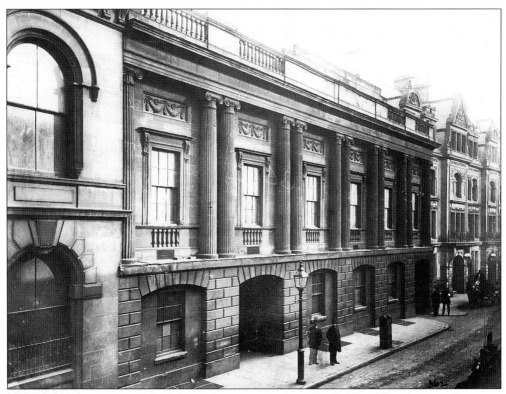

The Public Office in Moor Street, *c.* 1890.

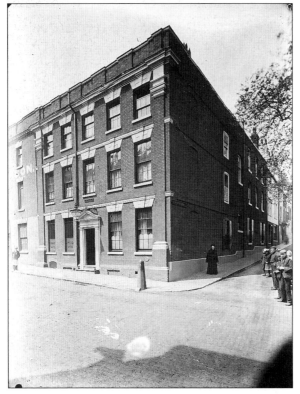

Dingley's Hotel in Moor Street, *c.* 1905, an establishment typical of the time providing meals and overnight lodgings in the days of leisurely travel.

Dingley's Hotel yard with a couple of porters posing for the camera …

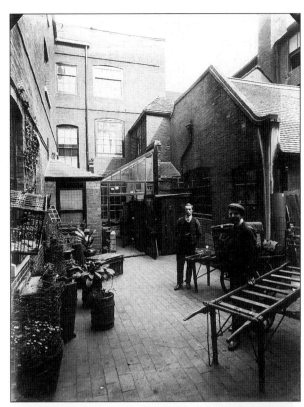

… and the other staff — including the hotel dog — more formally grouped.

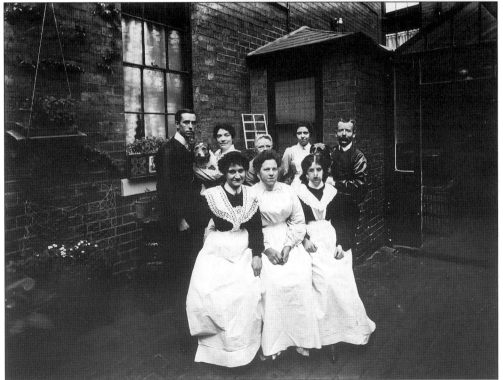

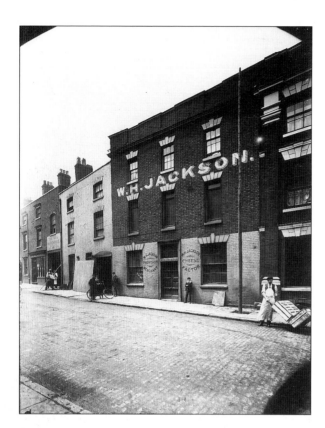

Next to Dingley's Hotel was Jackson's nail warehouse servicing the metalworking and building trades.

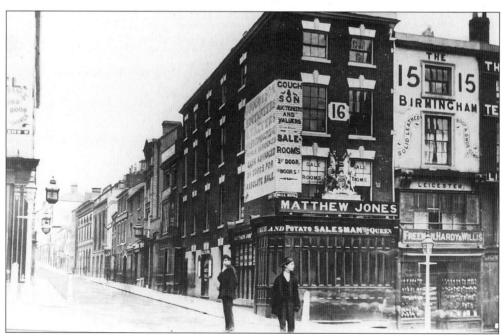

The corner of Moor Street and the Bull Ring, c. 1880.

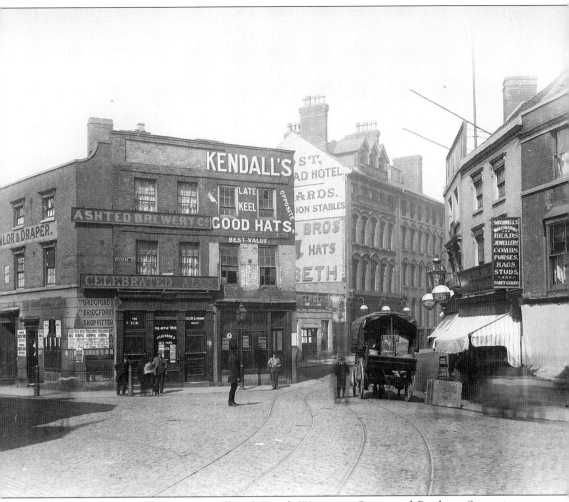

The junction of Dudley Street, Smallbrook Road, Worcester Street and Pershore Street just west of the Bull Ring, 1886.

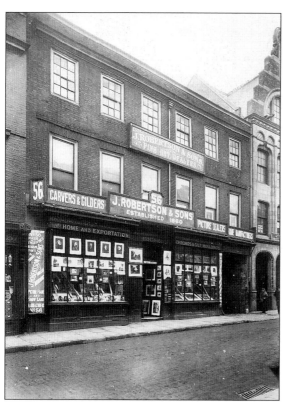

Immediately south of the Bull Ring is Edgbaston Street. No. 56 was the premises of Robertson's, fine art dealers.

Posters adorning the end of the Athletic Institute in John Bright Street, 1910.

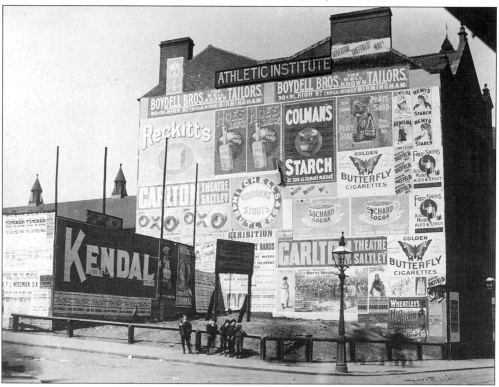

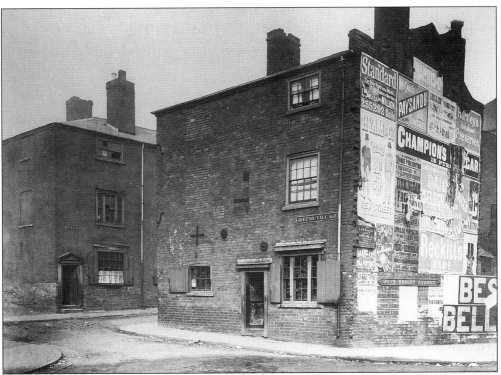

The corner of John Bright Street and Green Village (now Hill Street) in 1888, a year before the site was cleared.

The corner of John Bright Street and Navigation Street in what was formerly the Irish Quarter of the town.

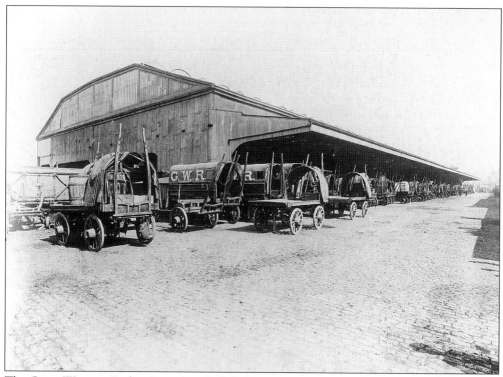

The Great Western Railway's yard in Suffolk Street.

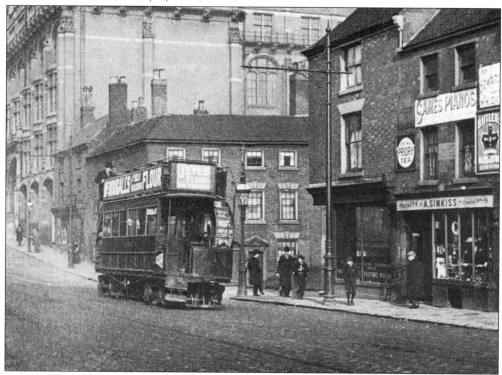

Suffolk Street at the turn of the century with a battery-electric tram bound for the Bristol Road.

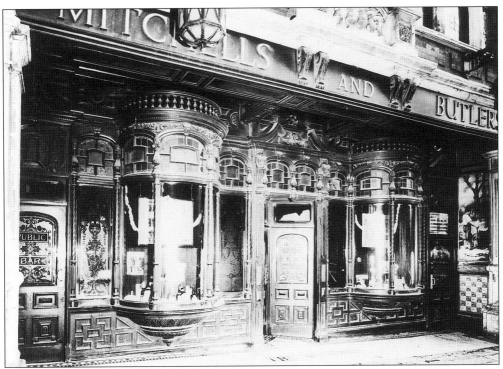

The Woodman in Easy Row at the northern end of Suffolk Street — just one of the city's thousand (almost) pubs. Such ornately-tiled frontages are, alas, now rarely to be found.

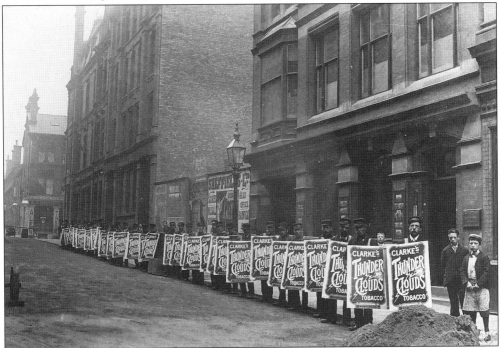

Just one of the city's thousand trades: sandwich-board men in 1897 preparing to set off on their daily round.

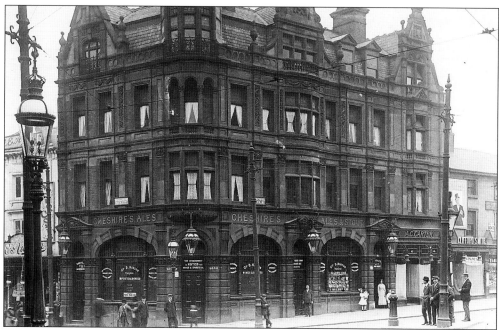

The Bull's Head Hotel on the Horse Fair, 1912. Staff living quarters were on the first floor, bedrooms on the second and the kitchens on the third!

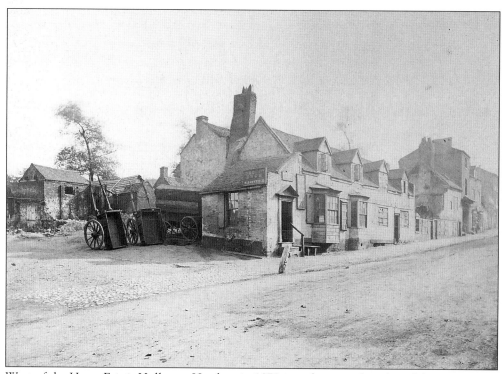

West of the Horse Fair is Holloway Head — in 1870 just about on the edge of the town.

46

Four

Main Streets

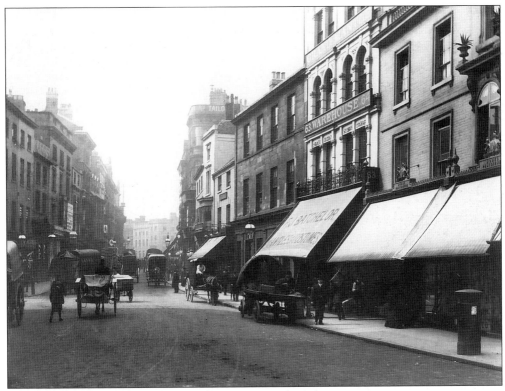

The High Street, *c.* 1903.

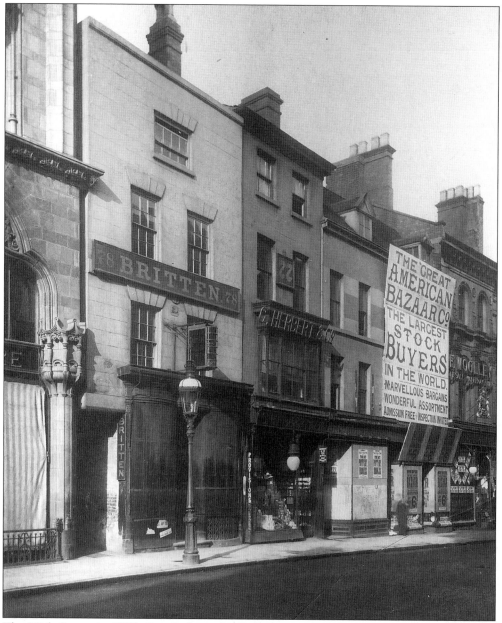

The High Street in 1897. Overlooking the Bull Ring and Digbeth, this was the old town's principal shopping thoroughfare.

Court House Yard off the High Street in 1892, looking towards the old Court House (demolished in 1903).

The old Court House in 1900 when occupied by Harris the printer and bookbinder. The Court Leet was formerly held here.

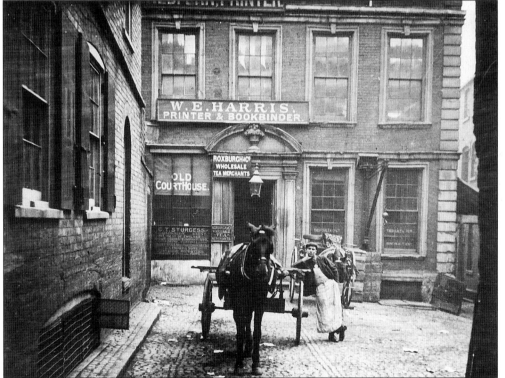

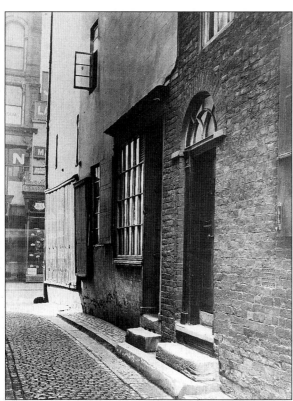

Looking back out from Court House Yard to the High Street, 1902.

New Street from its junction with the High Street, *c.* 1890. Despite its name, it was old by the fifteenth century.

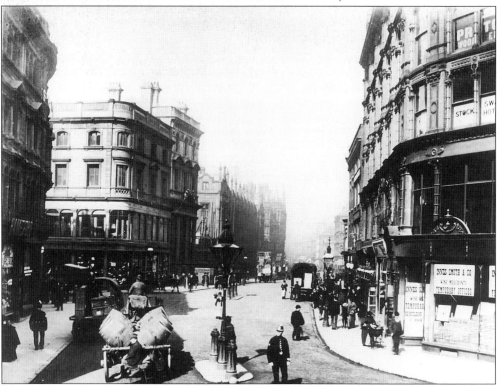

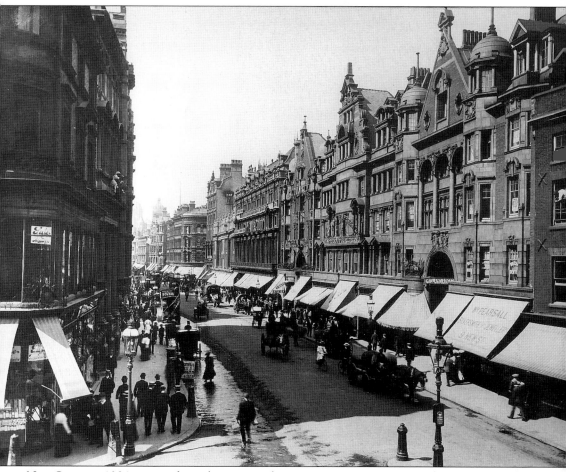

New Street *c.* 1904 as seen from the corner of Worcester Street just across the road from the High Street.

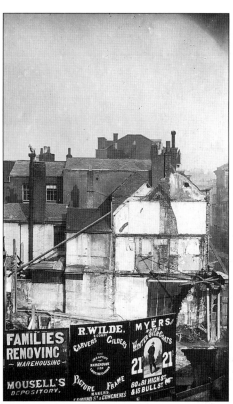

The corner of New Street and the High Street *c.* 1875 with a small example of Birmingham's continual redevelopment underway.

New Street from Corporation Street *c.* 1890, looking up the slope towards the Town Hall. Several of the buildings visible are still standing today.

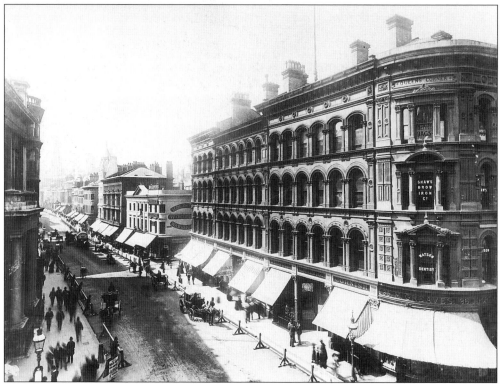

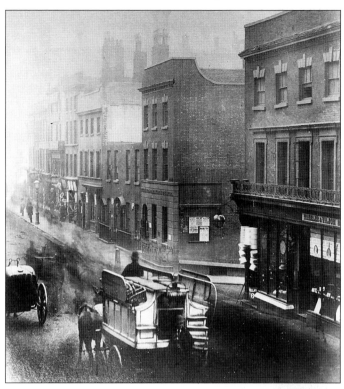

New Street, by contrast, in 1868 with a double-deck horse bus hard at work.

Cannon Street corner in 1892, the next side road up from Corporation Street.

53

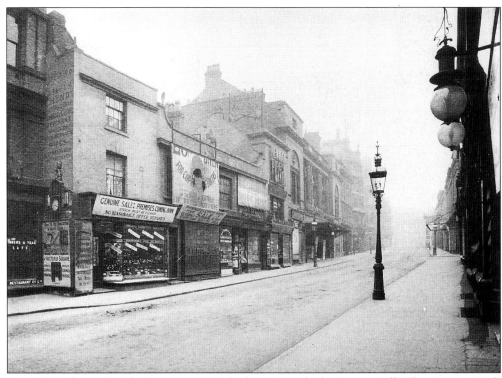

New Street from Temple Street, *c.* 1905, looking towards the Town Hall. This upper stretch was the last to be rebuilt before the First World War.

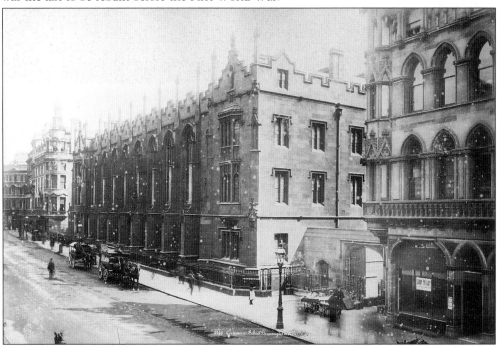

The Grammar School in New Street, *c.* 1890. Founded by Edward VI in 1552, this building (designed by Barry and Pugin) dated from the 1830s. The School moved to Edgbaston in 1935.

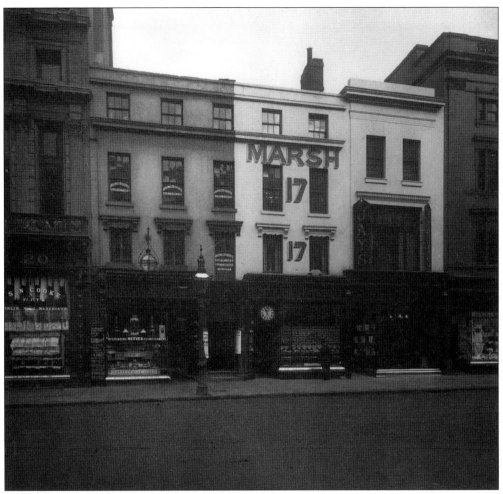

The premises opposite the Grammar School in 1897.

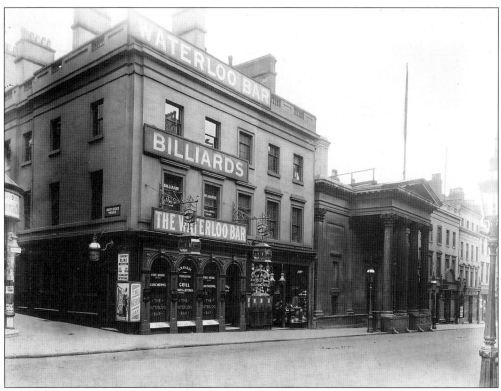

The Waterloo Bar and the imposing entrance to the Royal Birmingham Society of Artists' gallery, opened in 1829 and a direct influence on the choice of design for the new Town Hall.

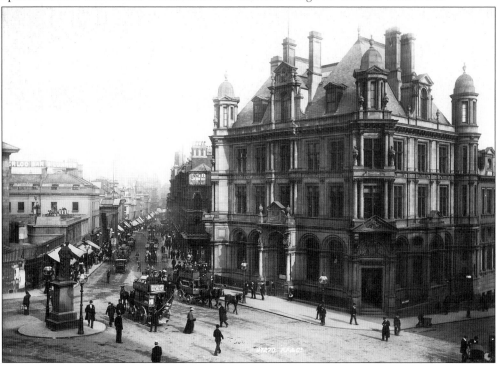

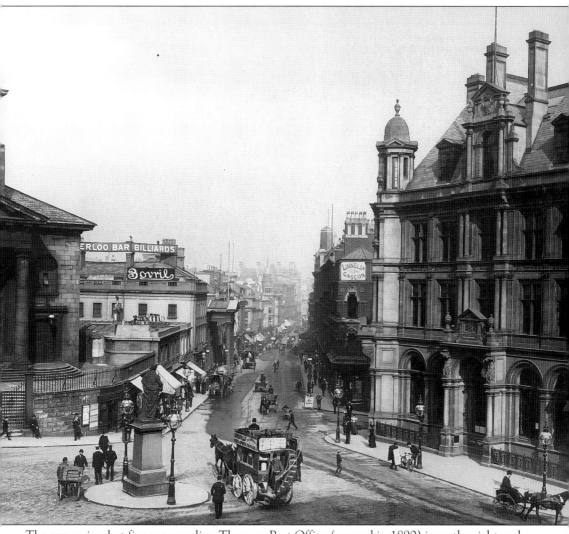

The same view but five years earlier. The new Post Office (opened in 1890) is on the right and Christ Church on the left. The statue of Sir Robert Peel is now outside the Police Training Centre in Pershore Road.

Opposite: The top of New Street around 1895 with several horse buses evident. The globes of the gas lamps presage the modern electric lights here.

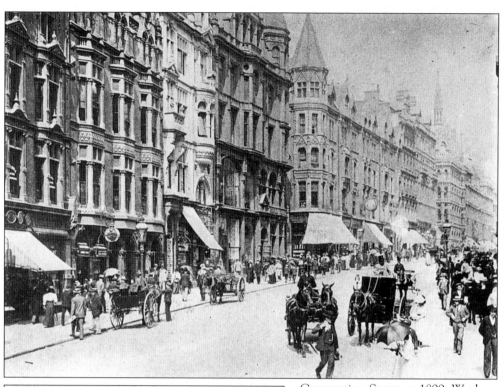

Corporation Street, *c.* 1899. Work began in 1878 on driving Corporation Street through the slums behind the High Street, working from both ends towards the middle.

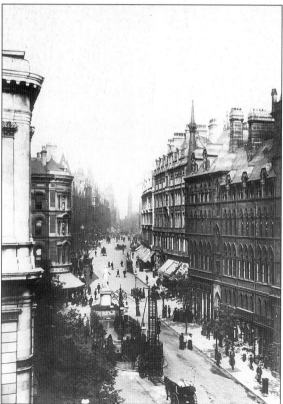

Looking up Stephenson's Place around 1900 past Queen's Corner into Corporation Street. The Midland Bank is on the left and the Exchange Building is on the right.

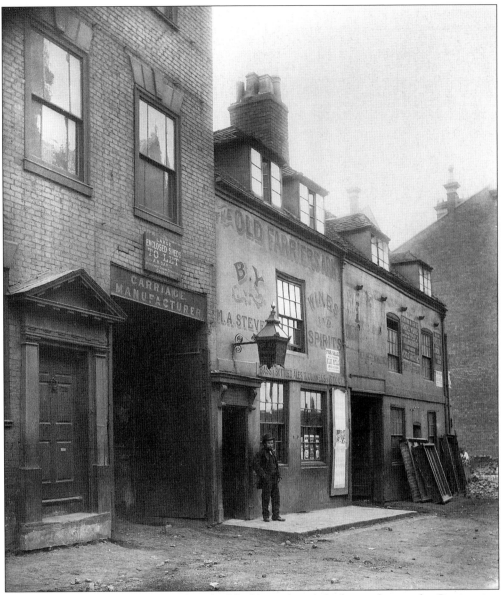

The Old Farriers Arms, one of six hundred buildings demolished to make way for Corporation Street, work on which was not completed until 1903.

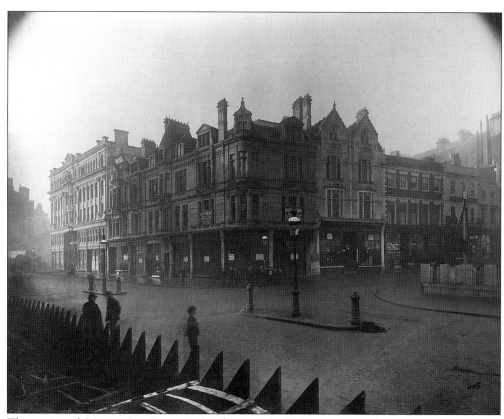

The corner of Corporation Street and Bull Street, *c.* 1890.

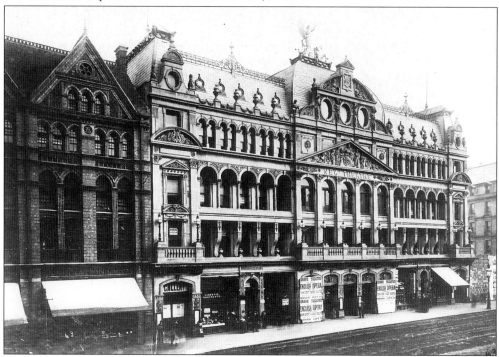

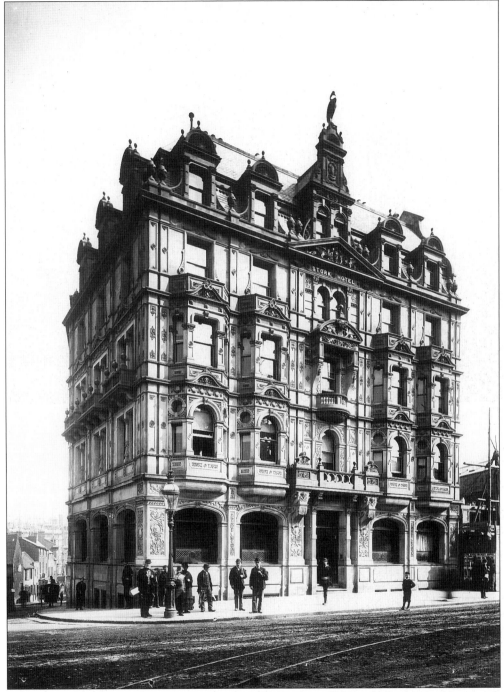

The Stork Hotel in Corporation Street, *c.* 1883. Another of the street's new buildings with construction work going on around it.

Opposite: The Grand Theatre in Corporation Street *c.* 1890, one of the impressive new buildings taking full advantage of this development opportunity.

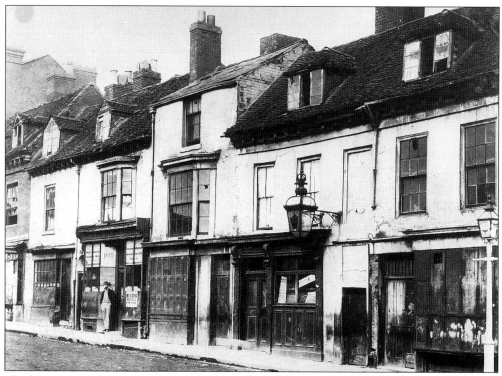

The lower end of Corporation Street (then Lichfield Street) *c.* 1870 before it was cleared.

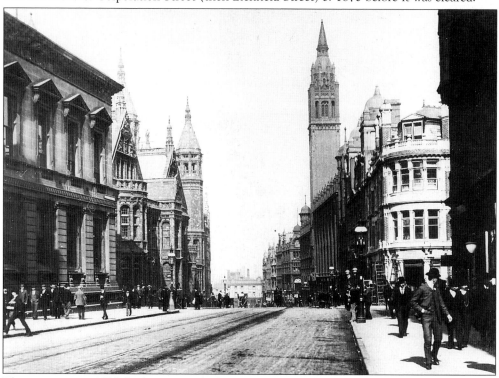

The same area *c.* 1895, looking towards the Law Courts and the Central Hall.

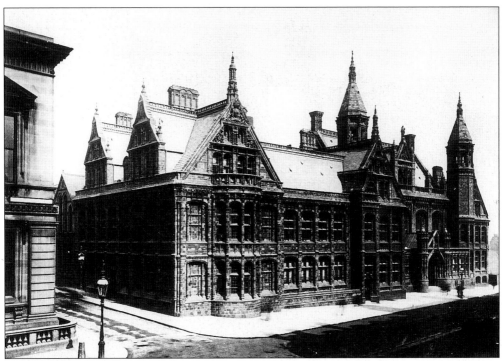

The new Victoria Law Courts in Corporation Street, *c.* 1880.

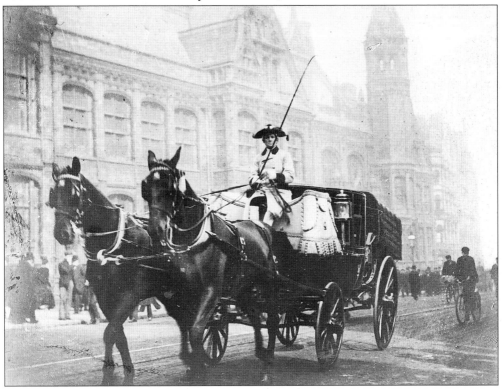

The Sheriff's carriage leaving the Law Courts after the 1904 March Assizes.

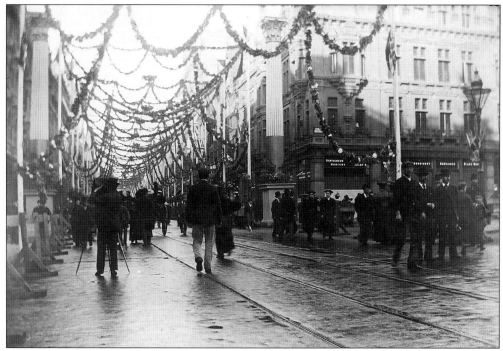

Corporation Street decorated for the opening of the General Hospital, by Queen Victoria's daughter Princess Christian of Schleswig-Holstein, in July 1897.

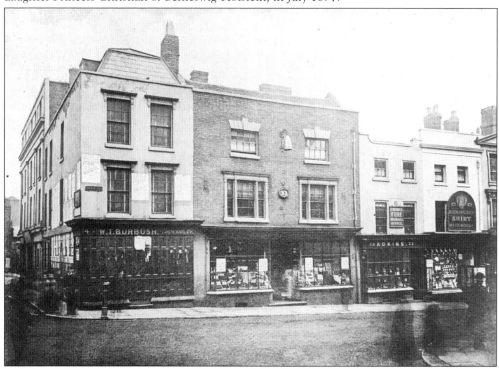

Bull Street, *c.* 1890, at the Minories (from the Augustine priory of St Thomas). Now heavily redeveloped, this was a short but important shopping street at the time…

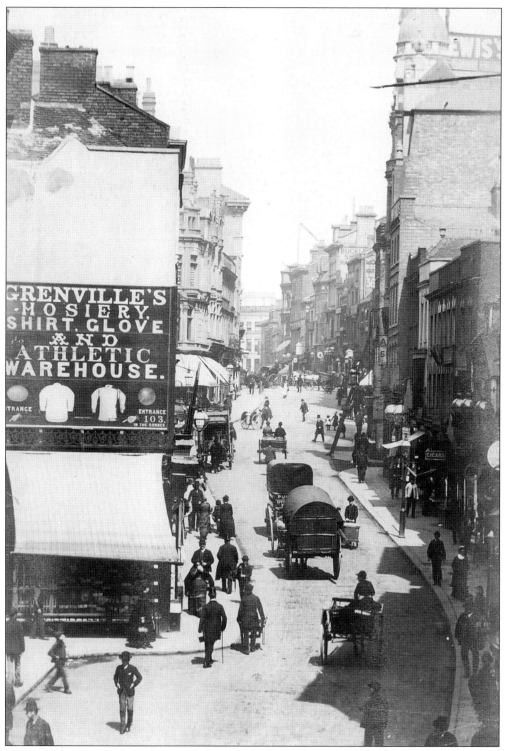

... as can be seen looking from Dale End at the same date. Formerly Chapel Street, the old priory site was latterly occupied by Lewis's department store.

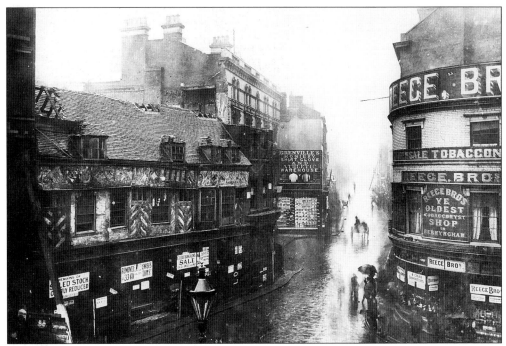

The old Lamb House on the corner of the High Street and Bull Street *c.* 1886 prior to its demolition.

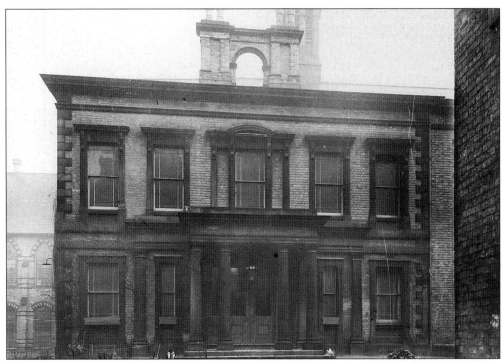

The Friends' Meeting-House in Bull Street. Opened in 1857 to replace an older building (and the sole Quaker meeting-house in Birmingham until 1873), it was rebuilt in turn in the 1930s.

James Wilson's bookshop
(established 1870) in Bull Street.
The outside …

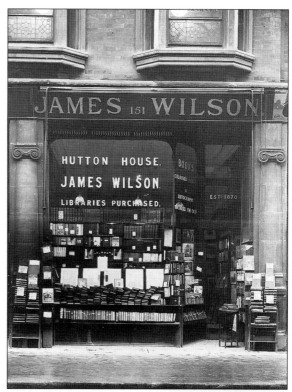

… and the inside.

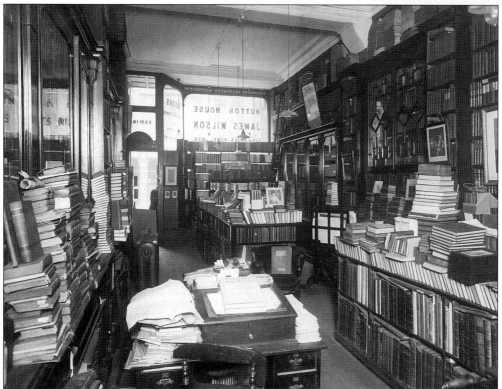

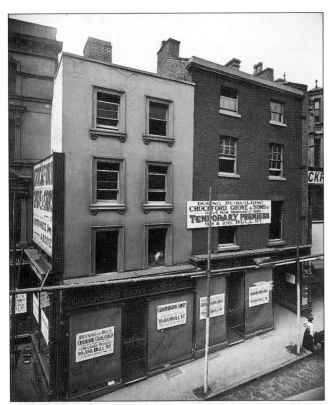

The front of the old
Crockford's building in Bull
Street, 1906, before it was
pulled down to make way for
…

… Crockford's new building a
year later.

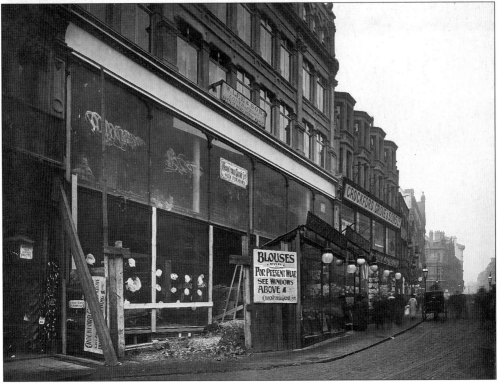

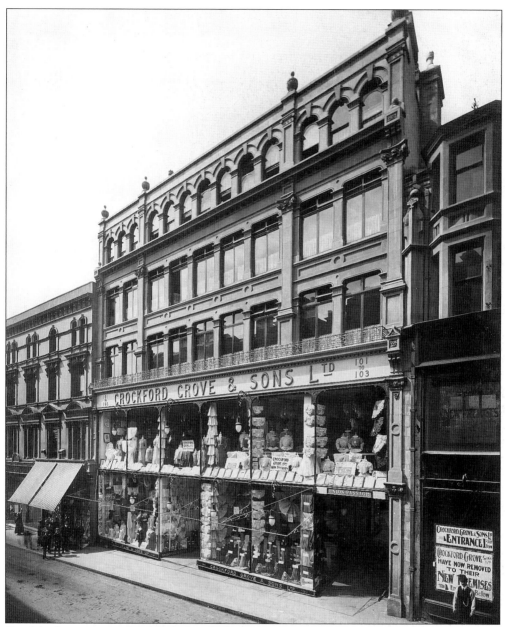

Crockford's store completed and open for business again, 1907.

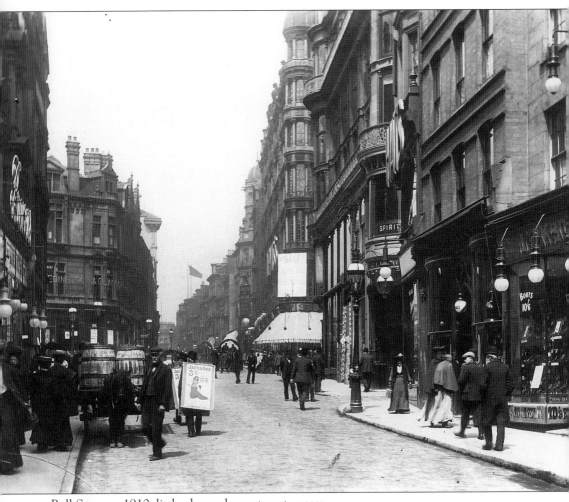

Bull Street *c*. 1910, little changed over twenty years.

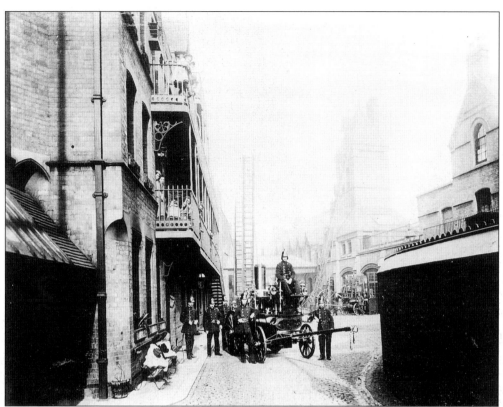

The 1885 fire brigade outside the Central Fire Station (opened two years earlier) in Upper Priory. The engine is a new horse-drawn Shard Mason steam pump.

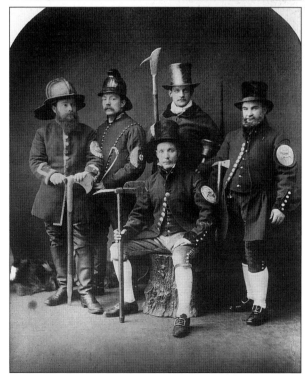

The Birmingham firemen posed in antique uniforms for this 1887 photograph commemorating Queen Victoria's visit.

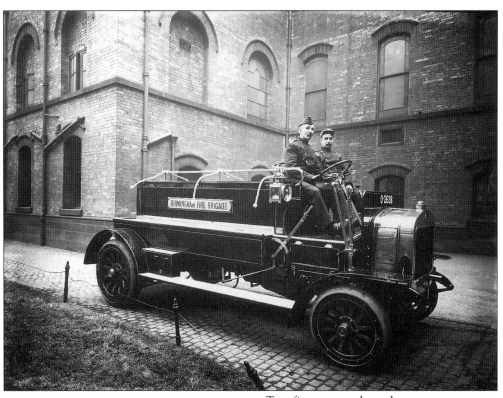

Two firemen at a later date atop a new, self-propelled engine.

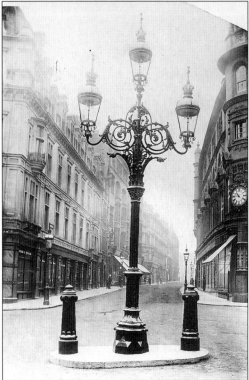

An ornate gas lamp standard in Old Square, *c.* 1900, a symbol of the city's new-found civic pride.

Five

And Back Alleys

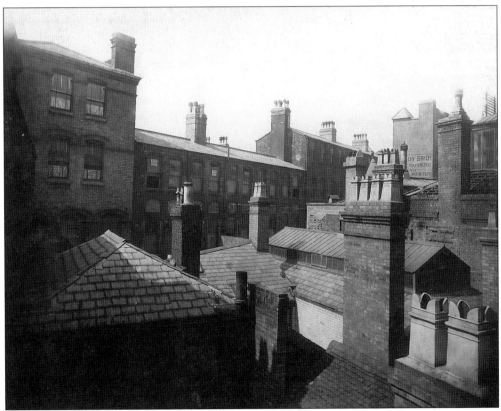

The Cannon Street rooftops in 1893, indicative of the maze of back streets and alleyways between the main shopping streets.

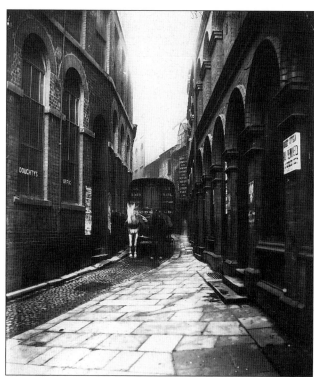

An atmospheric view of Needless Alley, only yards from the bustle of New Street.

Looking up a deserted Cannon Street from New Street in 1882.

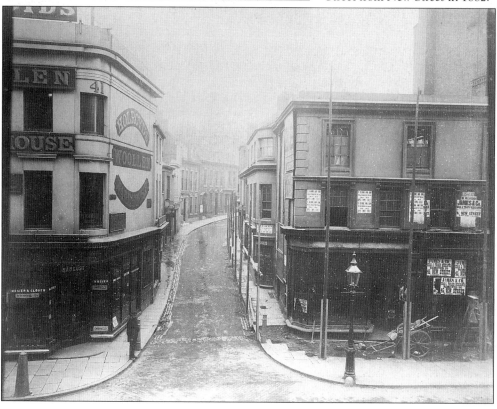

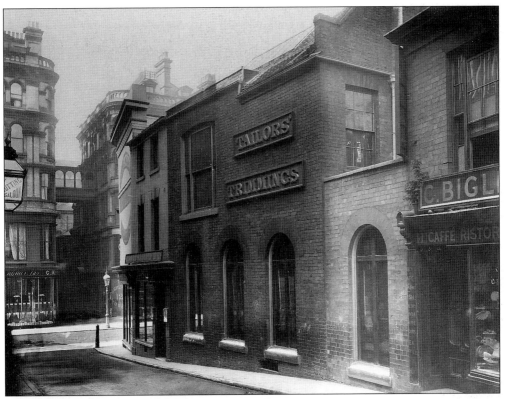

Cannon Street ten years later, looking into New Street.

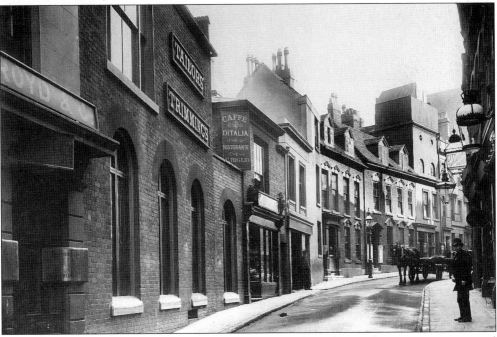

Cannon Street from New Street again, also in 1892, with evidence of increasing commercial activity.

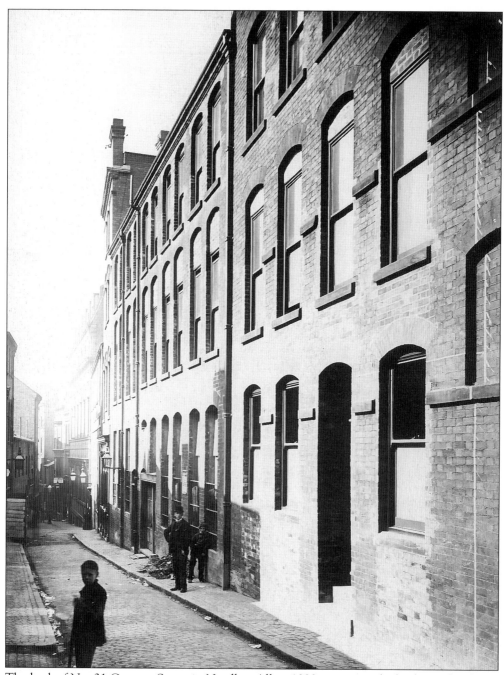

The back of No. 31 Cannon Street in Needless Alley, 1893 — a scene little changed today.

Union Passage, 1897 — a
view totally unrecognisable
today.

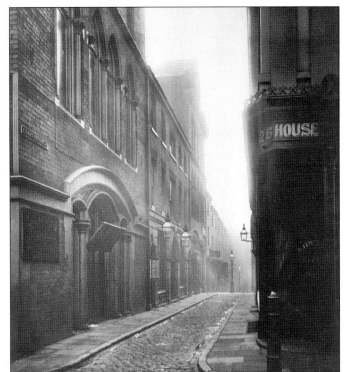

Cherry Street from
Corporation Street in 1887,
looking towards St Philip's.
Rackham's department store
is now on the right, the
Bank of England building
on the left.

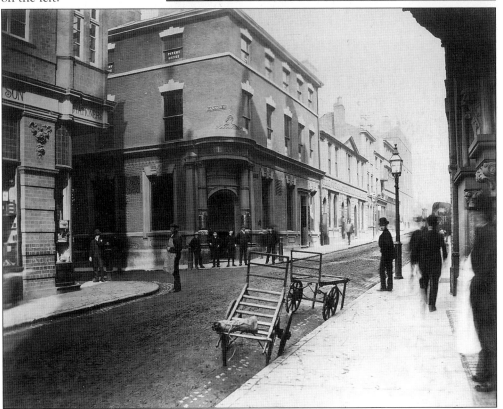

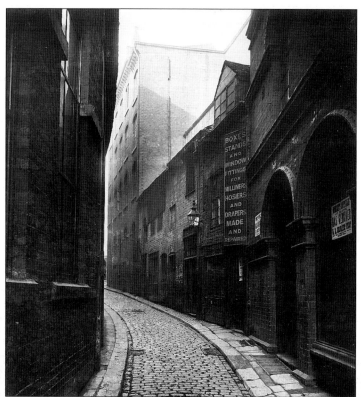

Crooked Lane, 1886, which once linked the High Street with Corporation Street, showing the old lock-up.

Union Passage in 1907 flanked by Crockford's and Horton's stores.

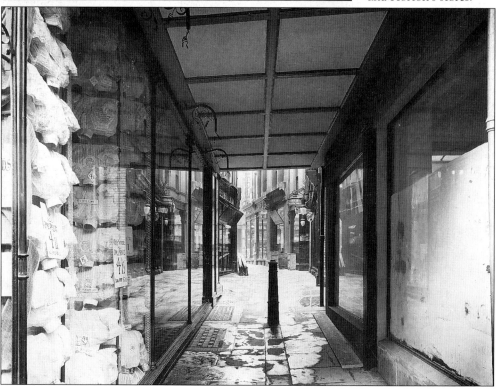

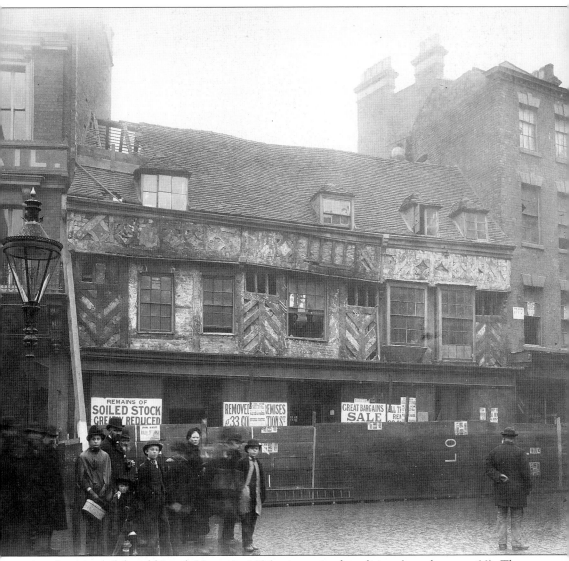

Another view of the old Lamb House in 1886 prior to its demolition (see also page 66). The last occupants were draper John Suffield and his wife (J.R.R. Tolkein's maternal grandparents).

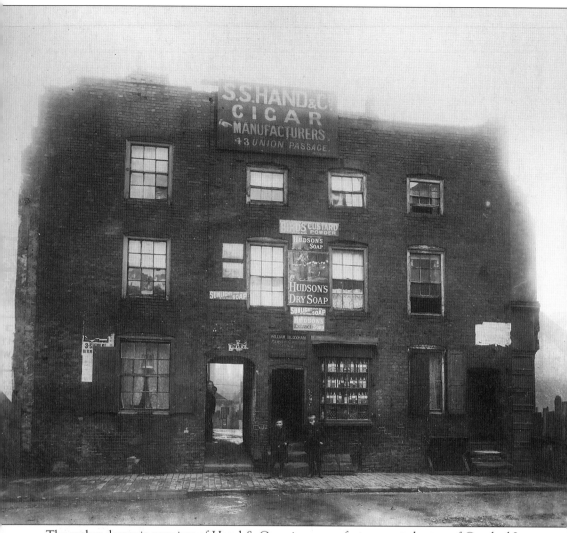

The rather decrepit premises of Hand & Co., cigar manufacturers, at the top of Crooked Lane (the corner of Martineau Square) in 1887.

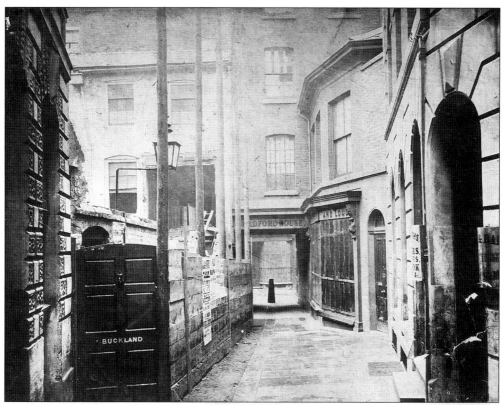

Union Passage looking towards
Bull Street in 1864 …

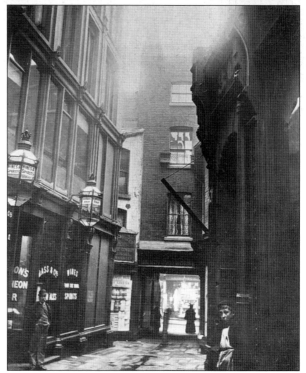

… in 1895 with Benson's bar now
erected on the left …

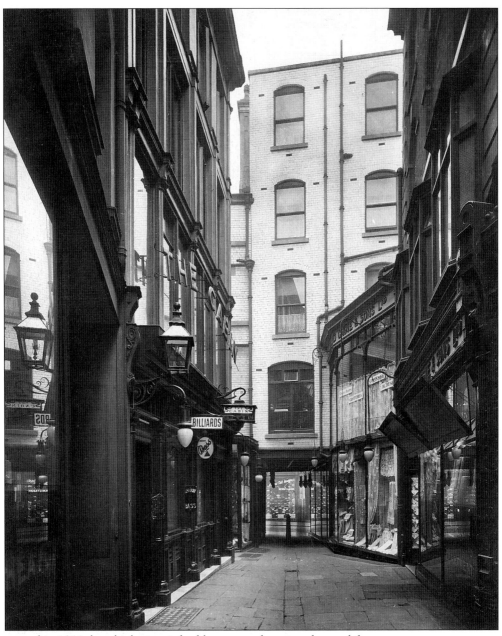

… and in 1911, by which time it had become a shopping thoroughfare.

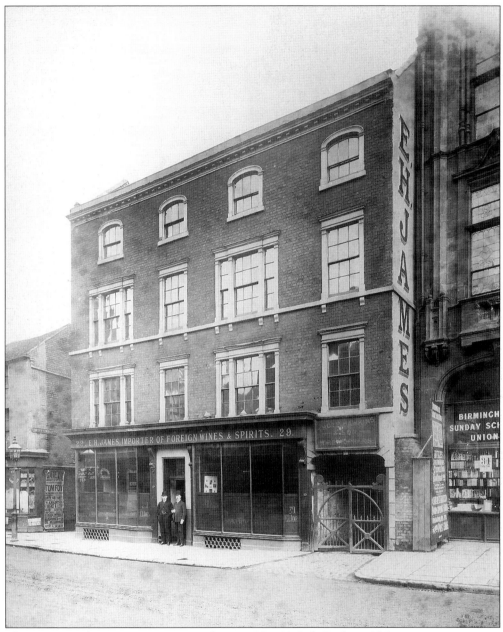

The premises of E.H. James, wine merchant, at No. 29 Dale End in 1906.

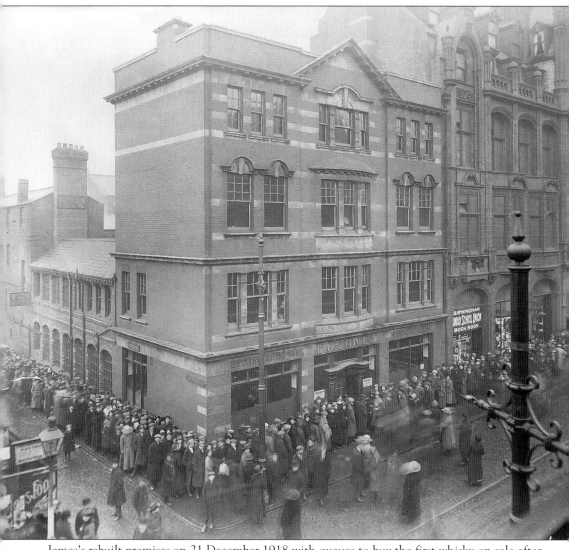

James's rebuilt premises on 21 December 1918 with queues to buy the first whisky on sale after the end of the First World War.

Six
All in a Row

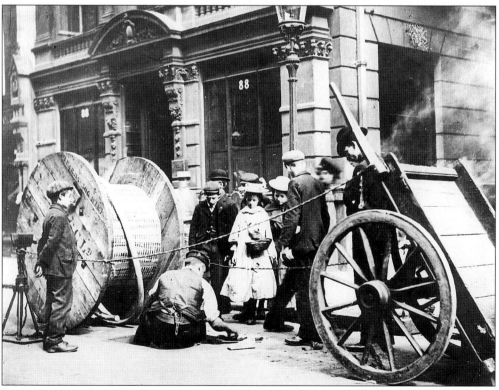

A small group of interested onlookers watch the new telephone cables being laid in Colmore Row in 1898 in the heart of Birmingham's financial district.

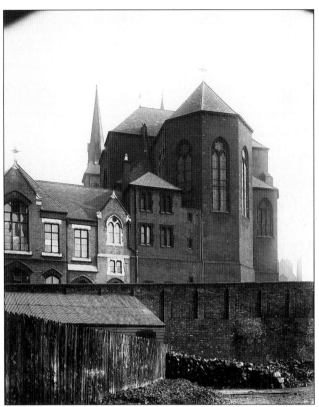

At the eastern end of the Colmore Row axis is St Chad's Cathedral, seen here in 1902 from the canal behind it. Designed by Pugin and consecrated in 1841, it was the first Roman Catholic cathedral to be built in England since the Reformation.

The Archbishop's House by St Chad's.

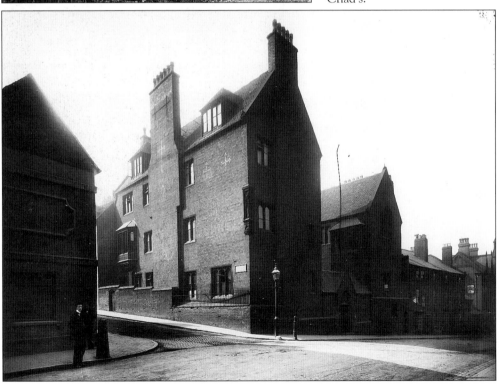

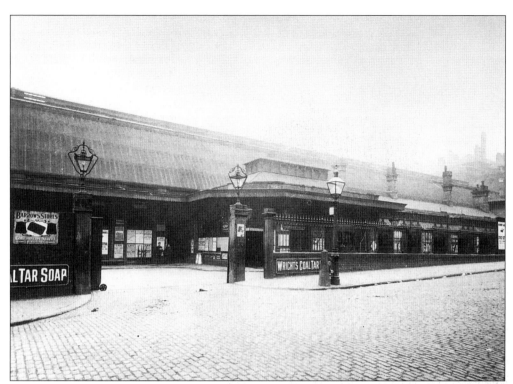

The Livery Street entrance of the Great Western Railway's Snow Hill station at the end of Colmore Row, 1909.

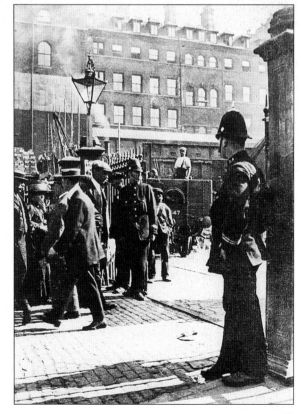

Police on picket duty at Snow Hill station during the 1911 railwaymen's strike.

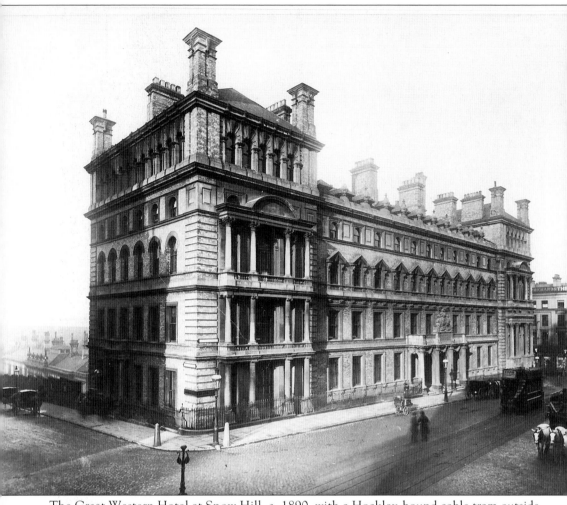

The Great Western Hotel at Snow Hill, *c.* 1890, with a Hockley-bound cable tram outside. The hotel was closed in 1905 to become the station's main entrance and was demolished in 1969.

The corner of Colmore Row and Livery Street with rebuilding work in progress, c. 1870.

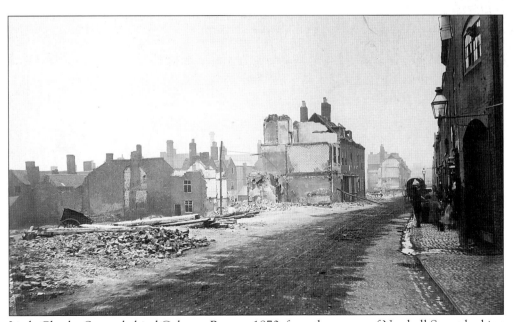

Little Charles Street, behind Colmore Row, c. 1870, from the corner of Newhall Street looking towards Livery Street.

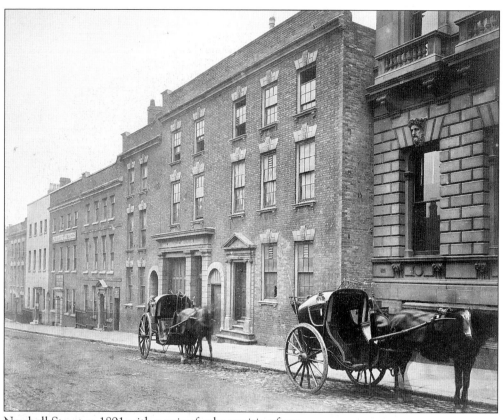

Newhall Street *c.* 1891 with a pair of cabs awaiting fares.

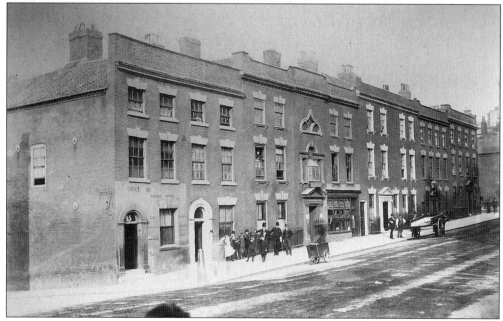

The east side of Newhall Street in 1887 looking towards Edmund Street from Bread Street (renamed Cornwall Street in 1897).

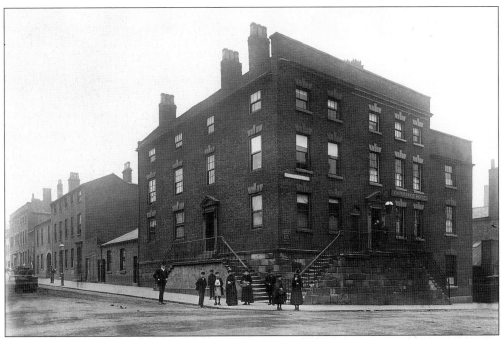

The corner of Newhall Street and Great Charles Street, *c*. 1900.

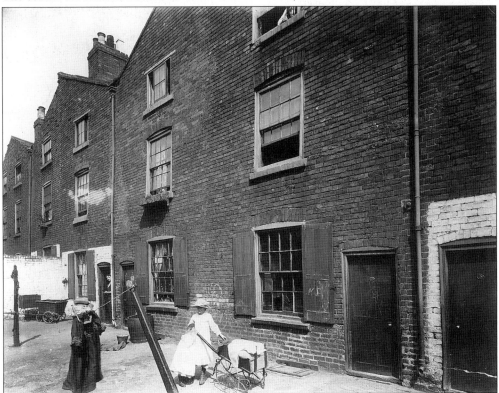

As recently as 1904 — when this photograph of No. 7 Court was taken — people were still living in Newhall Street.

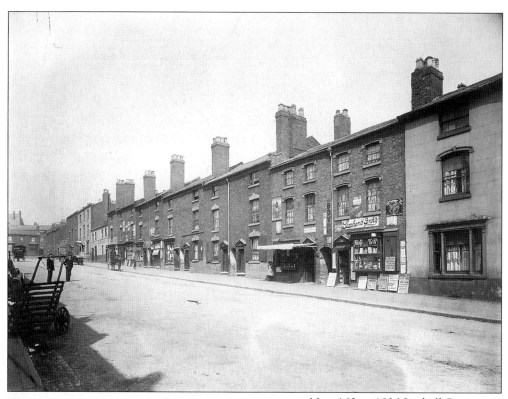

Nos. 163 to 183 Newhall Street, also in 1904.

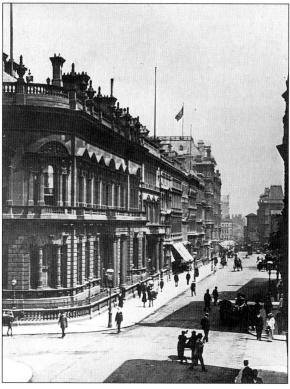

In contrast, Colmore Row (from Newhall Street) just a year later, a view easily recognisable today.

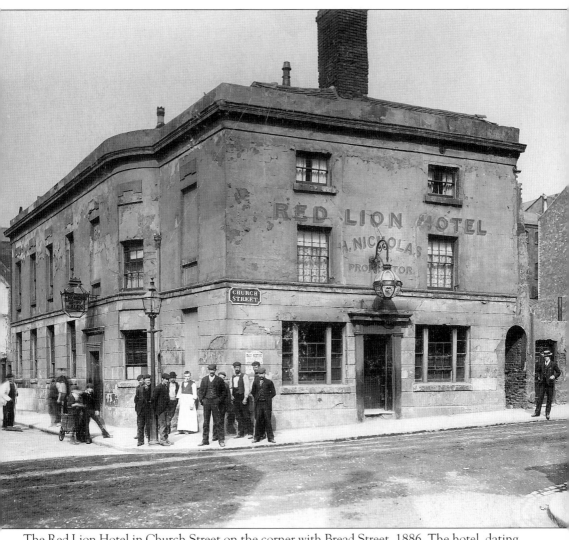

The Red Lion Hotel in Church Street on the corner with Bread Street, 1886. The hotel, dating from the 1840s, was demolished in 1898. It sold Homers beer from that brewery in Aston.

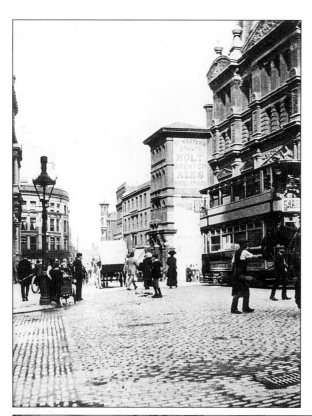

An electric tram outside the Great Western Vaults in Colmore Row in 1911, a year before the building was demolished.

The corner of Colmore Row and Temple Row in 1914 with the Town Hall in the distance. Again, a scene little changed today — apart from the absence of traffic.

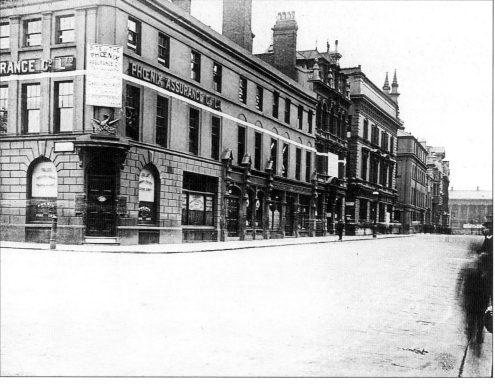

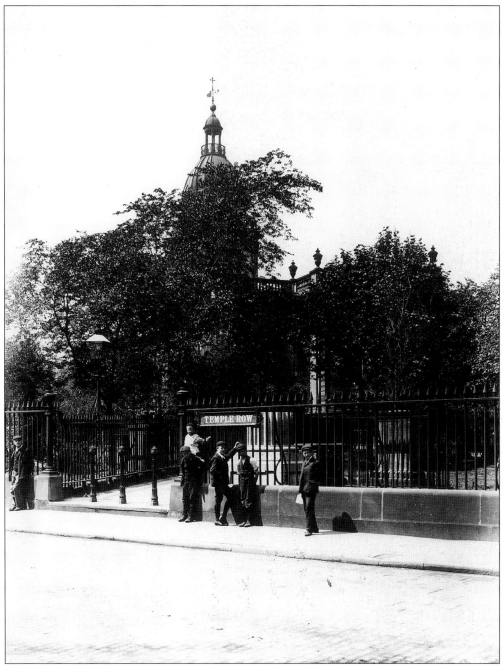

St Philip's church from Temple Row *c.* 1905, the year it became a cathedral.

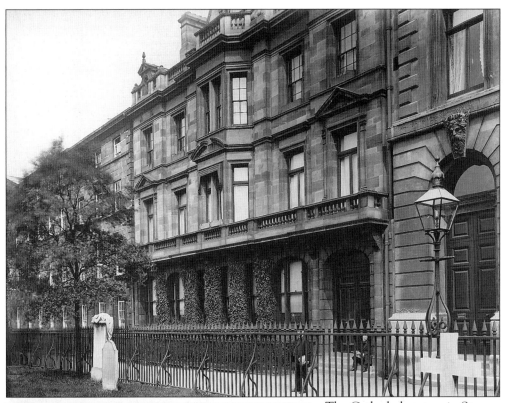

The Cathedral rectory in St
Philip's Place, 1910. Canon
Carnegie was rector at that time.

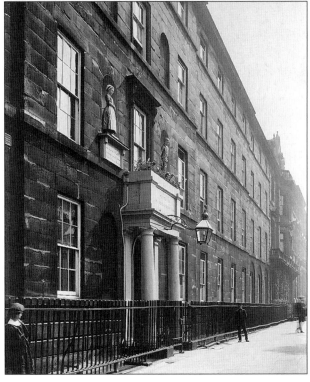

Birmingham Blue Coat School
overlooking St Philip's
churchyard in 1910, twenty years
before its closure.

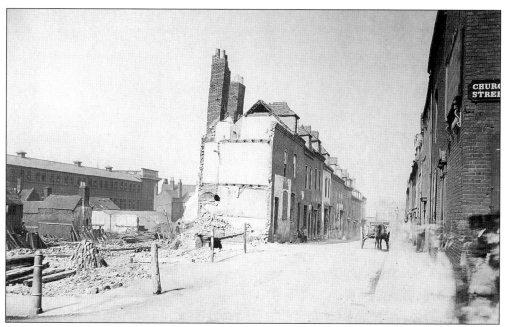

Little Charles Street from Church Street, *c.* 1870.

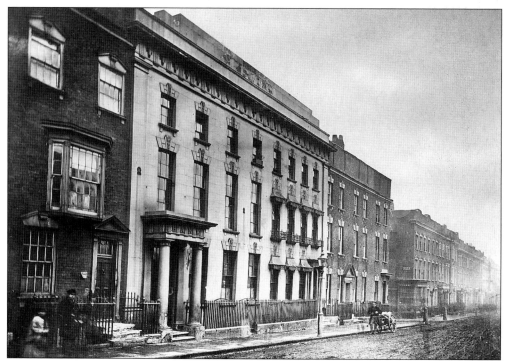

Colmore Row in 1869 (from near Church Street) before the reconstruction of the 1870s swept away the Georgian terraces.

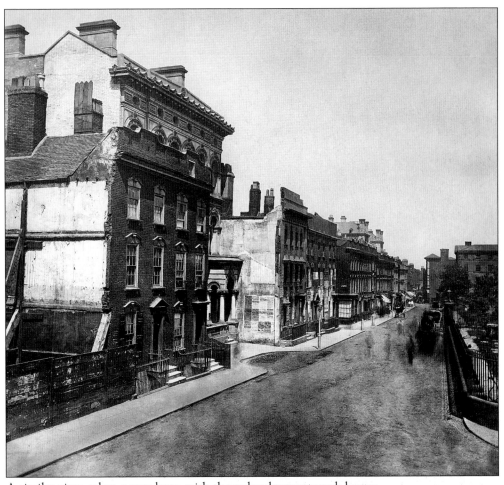

A similar view, taken a year later, with the redevelopment work begun.

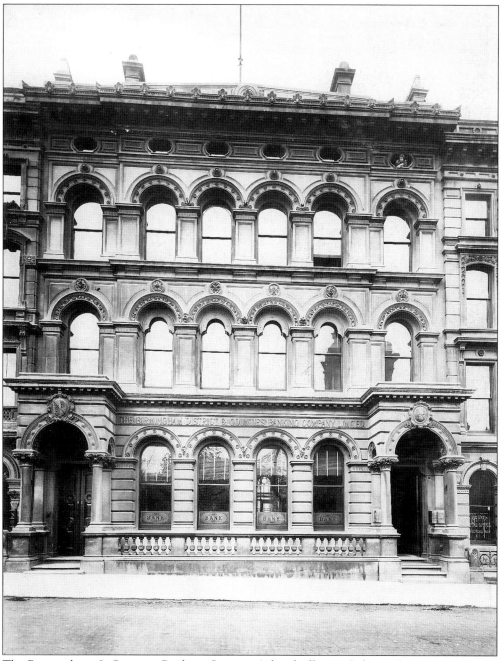

The Birmingham & Counties Banking Company's head office in Colmore Row.

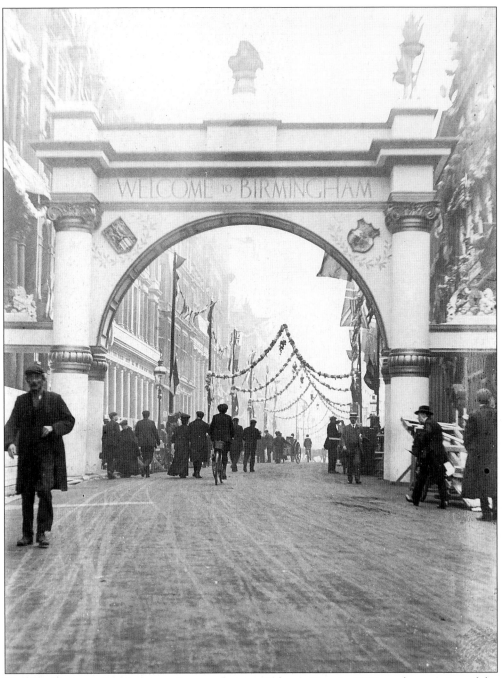

The Gas Company's welcome arch erected across Colmore Row in 1909 on the occasion of the visit of King Edward VII and Queen Alexandra to open the University of Birmingham.

Forging iron bedsteads at the Lionel Street premises of Fisher, Brown & Bayley Ltd in 1902 when the city's famous metalworking skills were still being carried out in the city centre.

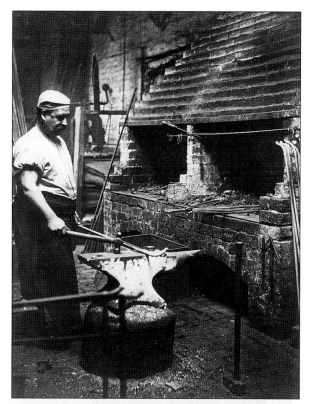

Packing the finished bedsteads for export. Not for nothing was Birmingham known as the 'Workshop of the World'.

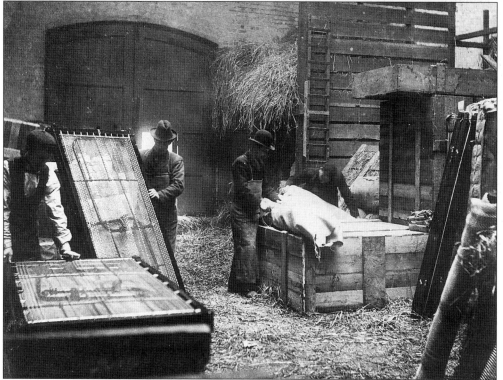

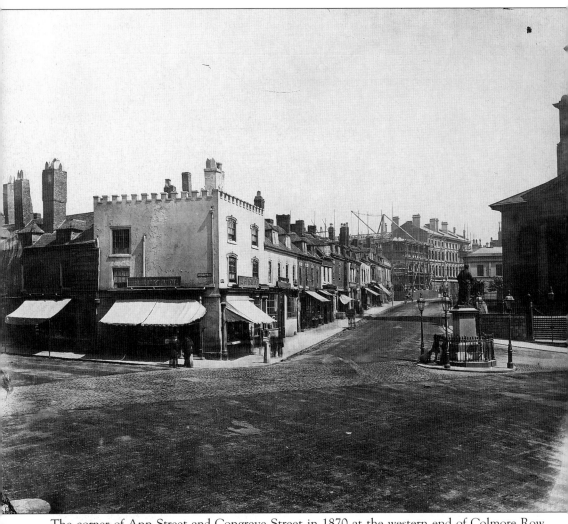

The corner of Ann Street and Congreve Street in 1870 at the western end of Colmore Row with Christ Church, built in 1805 and demolished in 1899, on the right.

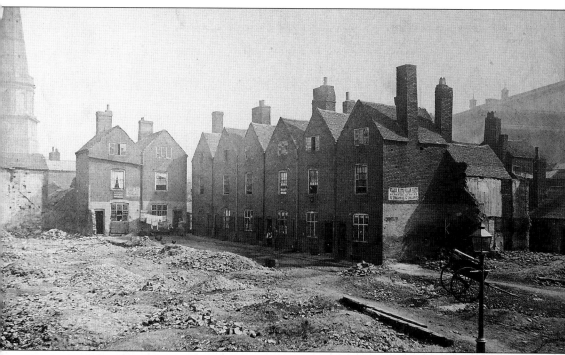

The back of Ann Street from Congreve Street in 1871 with preparatory work for building the Council House begun.

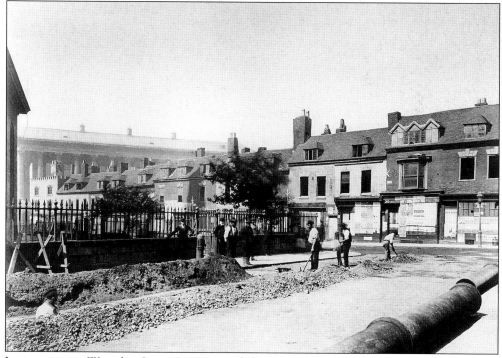

Laying pipes in Waterloo Street in 1873, probably in conjunction with clearing Ann Street to make way for the Council House.

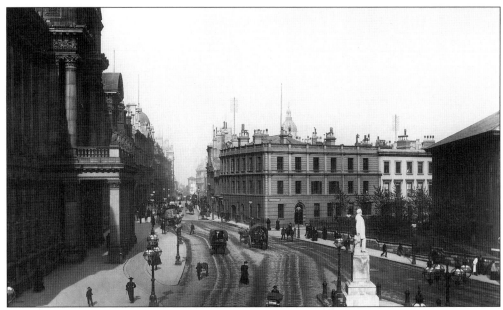

Colmore Row and Waterloo Street in 1896, looking from the Council House. The redevelopment is, for the time being, complete.

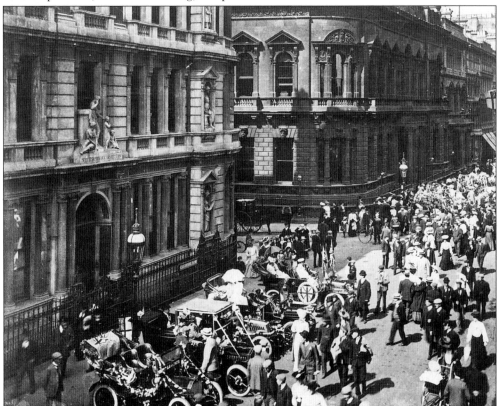

Colmore Row celebrations on 8 July 1906 to mark the seventieth birthday of Joseph Chamberlain, one of the city's most eminent sons.

Seven

The Civic Centre

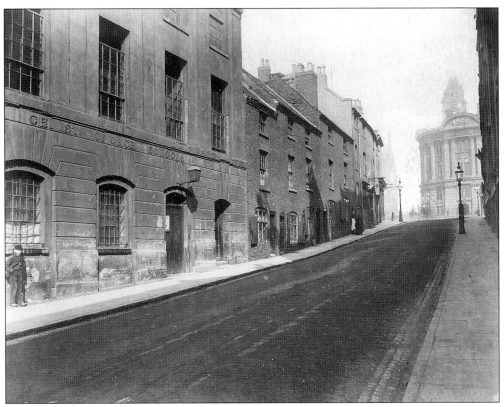

The site of the new Post Office in Pinfold Street, 1887, looking up to the Council House with Christ Church Schools on the left.

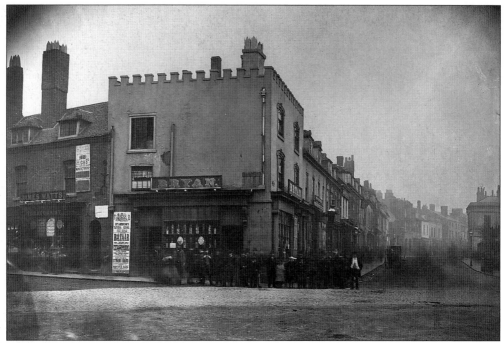

The corner of Congreve Street and Ann Street in the 1860s in what was to become, ten years later, the new heart of the town.

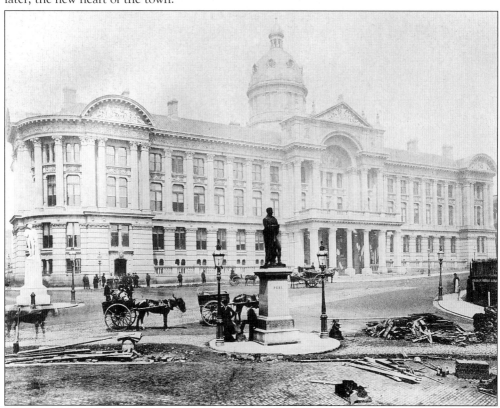

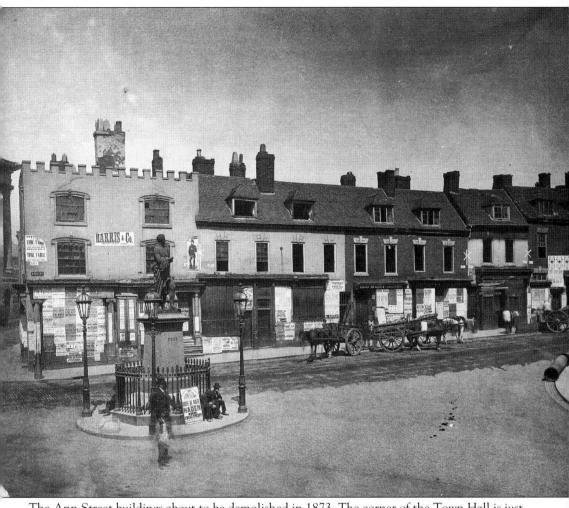

The Ann Street buildings about to be demolished in 1873. The corner of the Town Hall is just visible on the left.

Opposite: The Council House shortly after its 1879 completion.

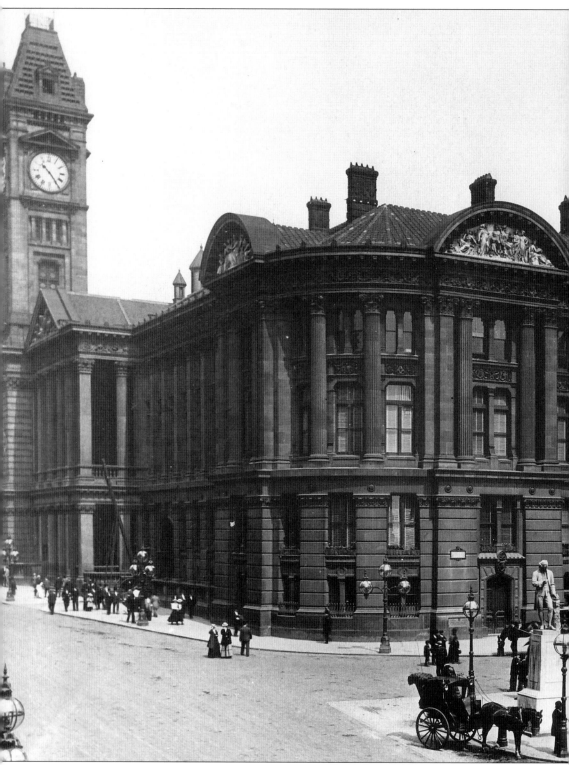

The full sweep of the Council House and Victoria Square with the Queen's statue in place of honour.

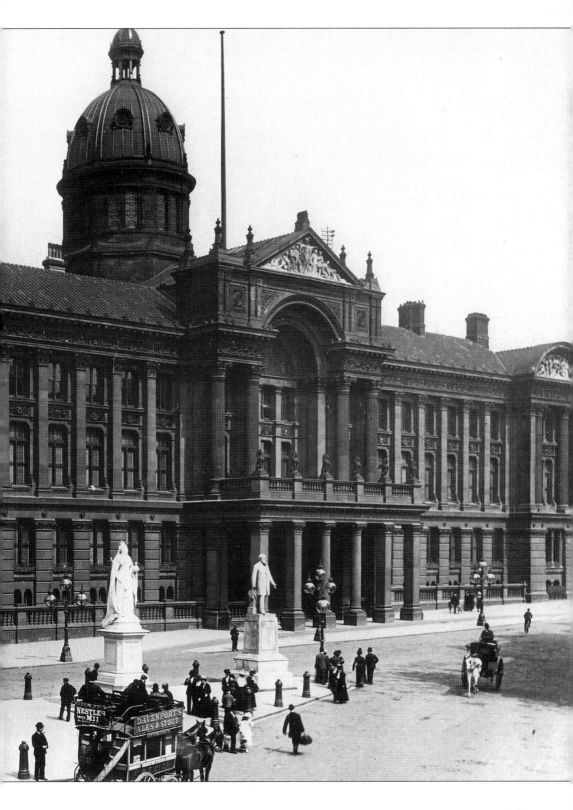

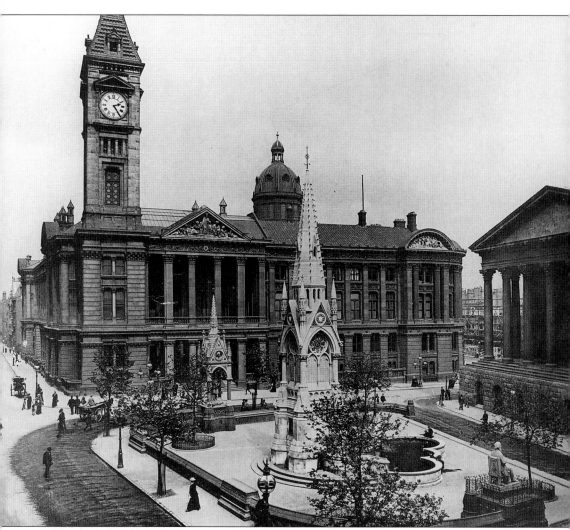

The side elevation of the Council House and 'Big Brum' *c.* 1895 showing the entrance to the Museum and Art Gallery (opened 1885) and the Chamberlain Memorial (1880).

Opposite: Behind the scenes – the Council House yard *c.* 1905.

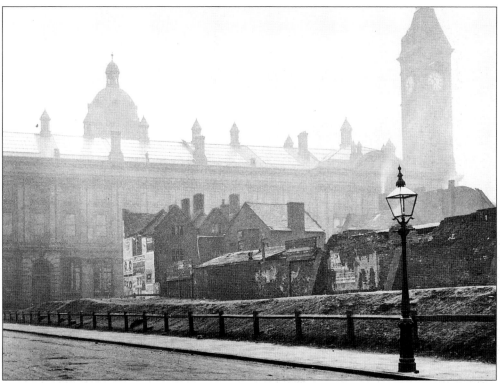

As late as 1909 the area behind the Council House (in this case Margaret Street) had still not been redeveloped after the 1870s slum clearances.

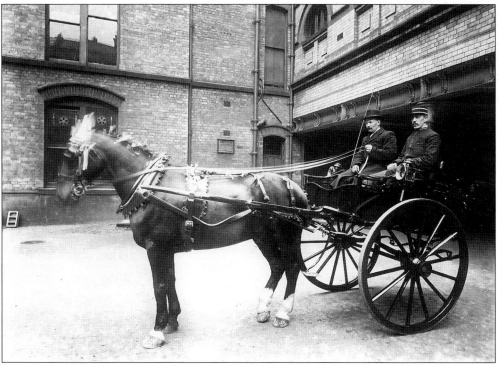

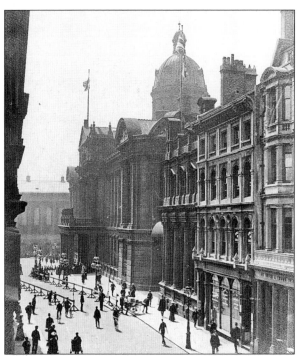

Erecting barriers outside the Council House in 1906 for the Joseph Chamberlain's seventieth birthday celebrations.

The 1909 visit of King Edward VII, here leaving the Council House after a civic lunch to open the new University of Birmingham.

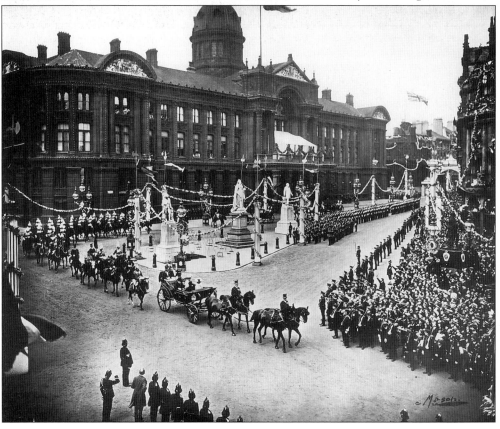

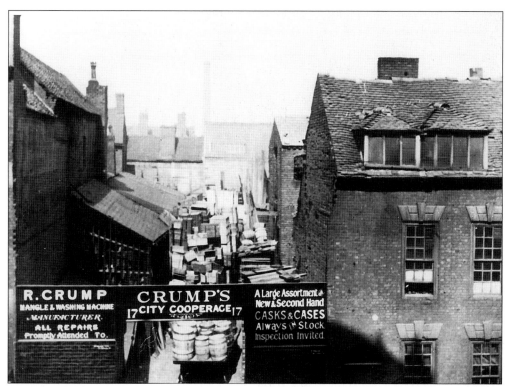

A works yard in Art Gallery Street off Edmund Street, a stone's throw from the new Council House.

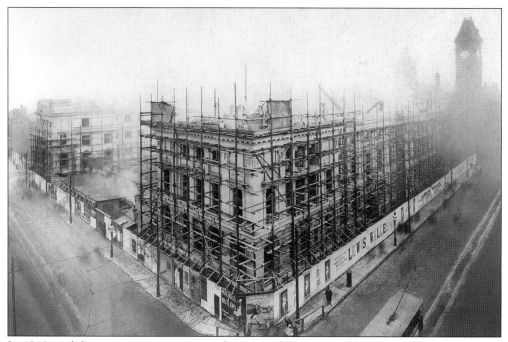

In 1910 work began on an extension to the Council House, on the corner of Congreve Street (right) and Great Charles Street (left).

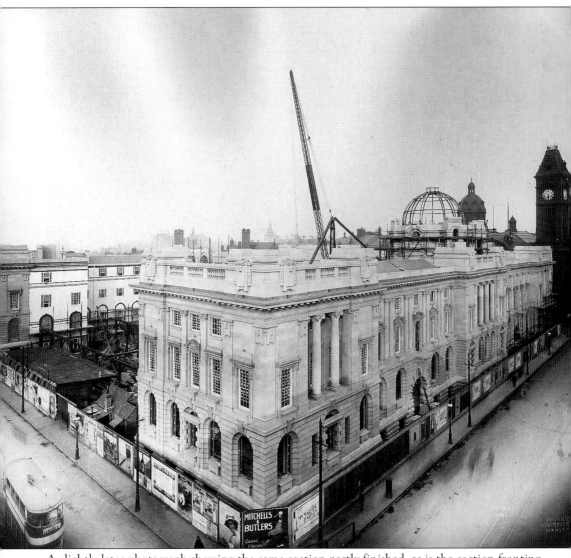

A slightly later photograph showing the same section partly finished, as is the section fronting Margaret Street in the distance.

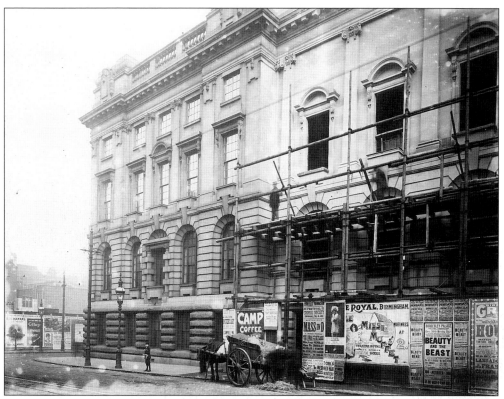

Work continuing on the Great Charles Street frontage shortly before the extension's 1912 opening.

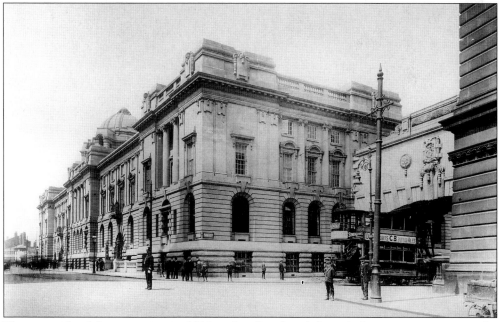

The west side of the extension in 1911 with a Smethwick-bound electric tram passing under the bridge to the Museum and Art Gallery.

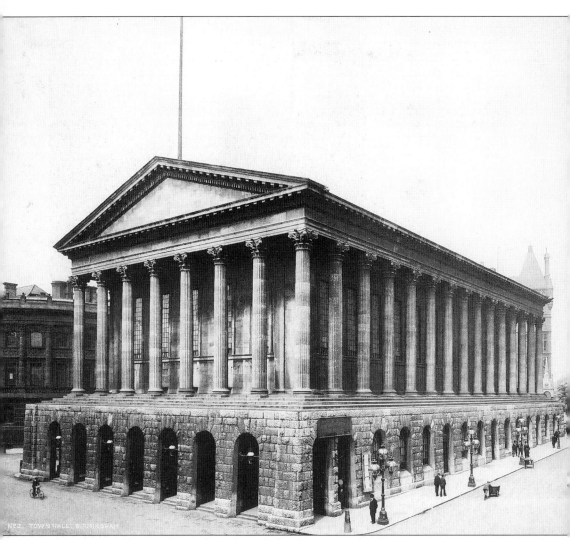

The Town Hall *c.* 1910. Based on the temple of Castor and Pollux in Rome, it was completed in 1834 after two years' work. It has been little altered since, despite repeated changes to its immediate setting.

Looking from the top of New Street down Paradise Street to the Town Hall in 1886.

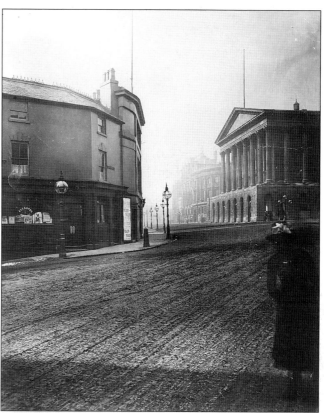

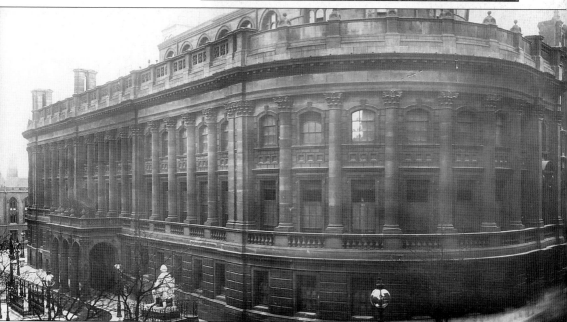

Behind the Town Hall was the Central Library, rebuilt in 1882 after a disastrous fire, remembered with affection by many and demolished in the 1970s to make way for a short length of road.

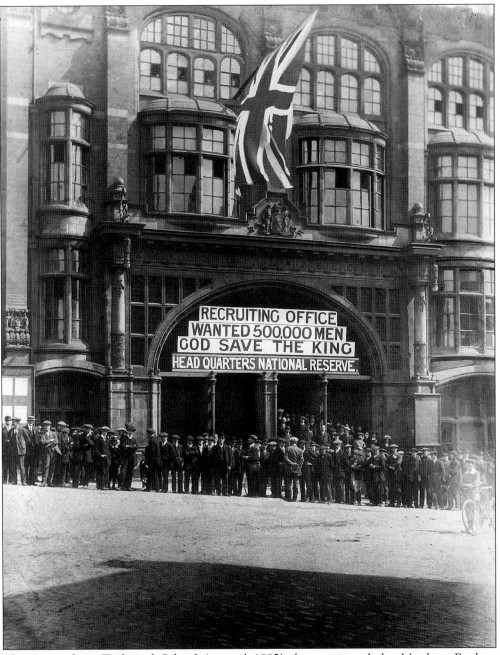

The Birmingham Technical School (opened 1895), later renamed the Matthew Boulton Technical College, pressed into service as a First World War recruiting office.

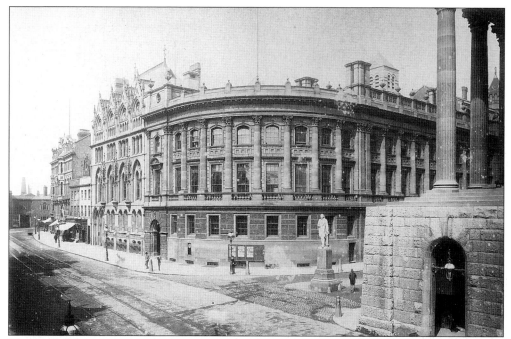

The Midland Institute beside the Town Hall, *c.* 1890.

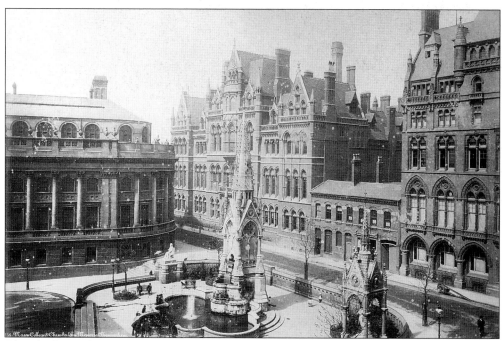

Chamberlain Place *c.* 1892 looking towards Mason's College — the forerunner of the University of Birmingham — in Edmund Street (now the site of the new Central Library).

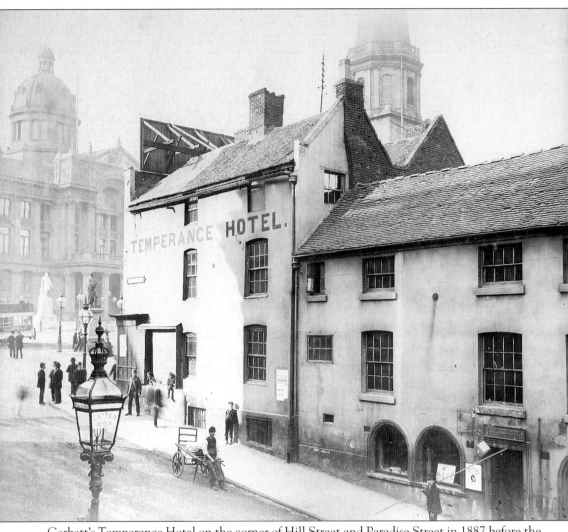

Corbett's Temperance Hotel on the corner of Hill Street and Paradise Street in 1887 before the site was cleared for the new Post Office (opened 1890).

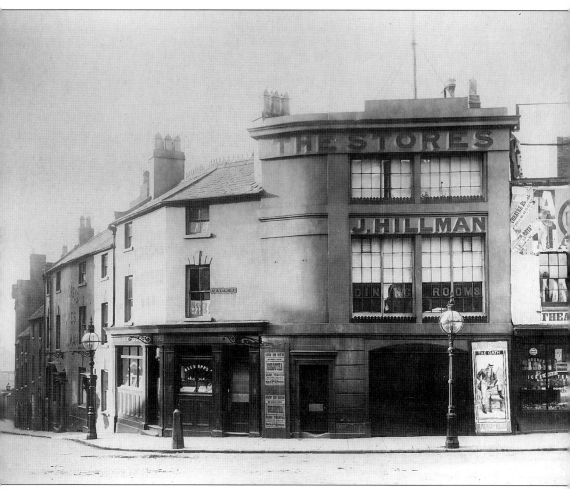

Farther round the corner into Paradise Street, showing the adjoining Hillman's Stores and Dining Rooms …

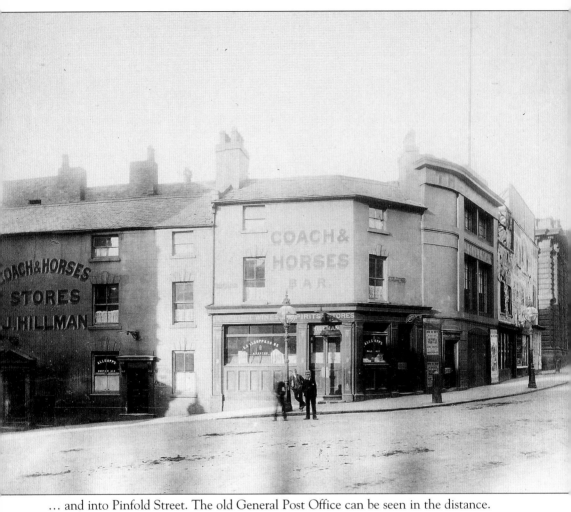

… and into Pinfold Street. The old General Post Office can be seen in the distance.

Eight

Way Out West

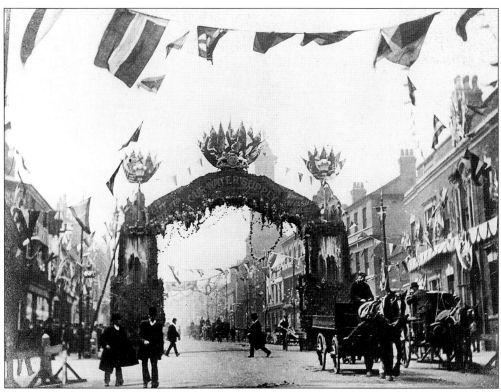

The Water Department's arch outside its offices in Broad Street welcoming the July 1909 visit of King Edward VII and Queen Alexandra.

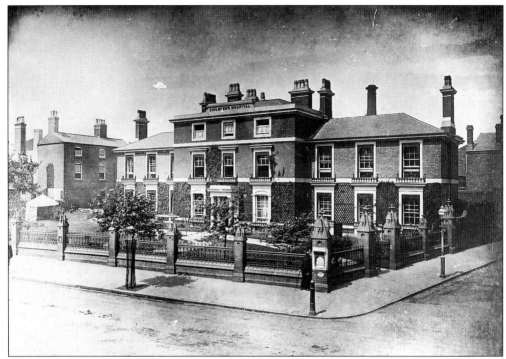

The Children's Hospital in Broad Street, the historic western approach to Birmingham, *c.* 1890 before it moved further west off Five Ways.

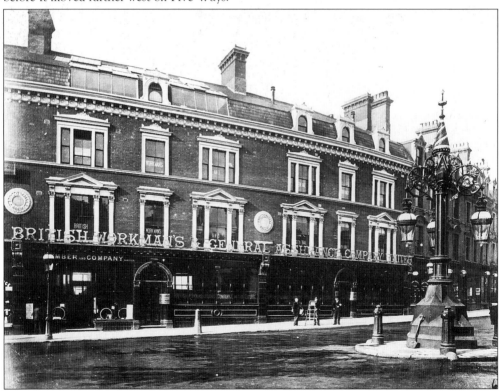

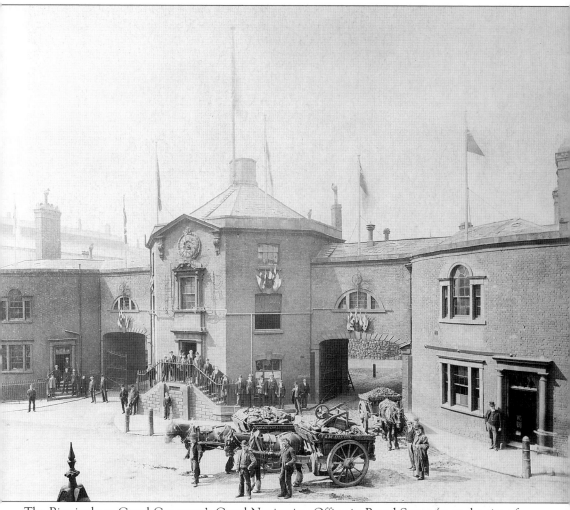

The Birmingham Canal Company's Canal Navigation Office in Broad Street (now the site of Alpha Tower) in 1907. The pipes across the front of the building are for the gas lighting.

Opposite: The British Workman's & General Assurance Company's offices on Broad Street Corner *c.* 1896.

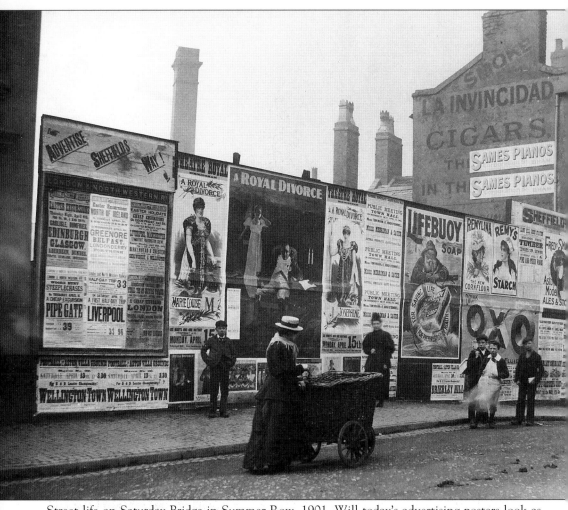

Street life on Saturday Bridge in Summer Row, 1901. Will today's advertising posters look as appealing a hundred years hence?

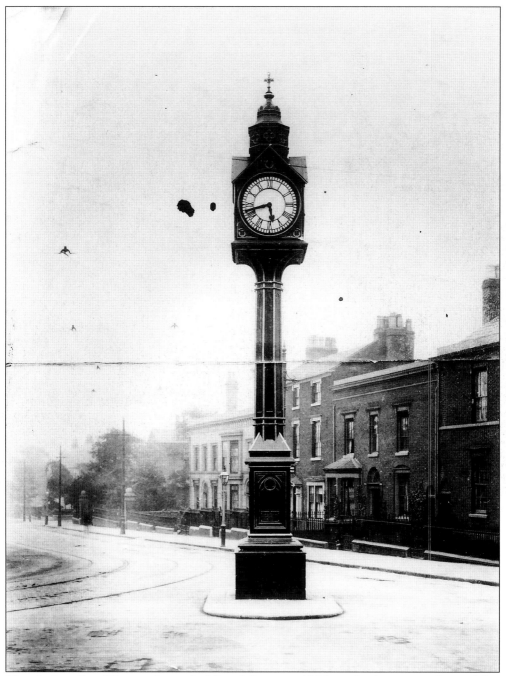

The clock at Five Ways at the end of Broad Street, *c*. 1906, marks the western limit of this photo selection — and the direction in which the city centre is slowly but steadily heading.

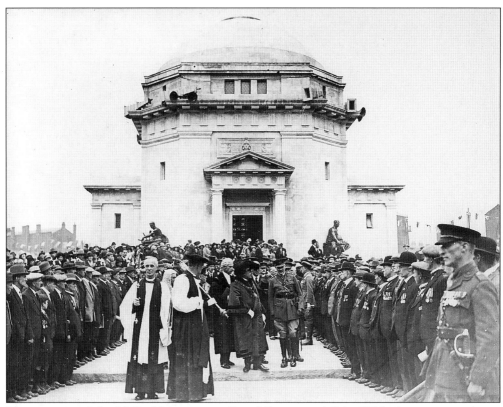

The opening of the Hall of Memory on Broad Street on 4 July 1925, the ceremony being performed by Prince Arthur of Connaught.

Acknowledgements

My thanks go to my colleagues Martin Flynn, Margaret Donnison and Robert Ryland for all their help and encouragement, without which this book would never have been completed.